MW00380317

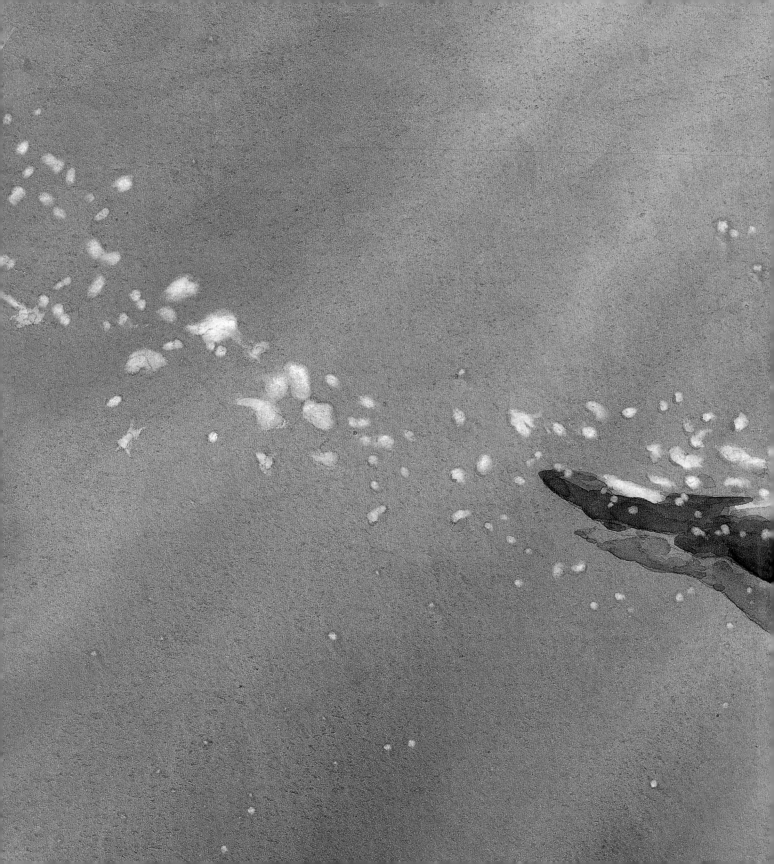

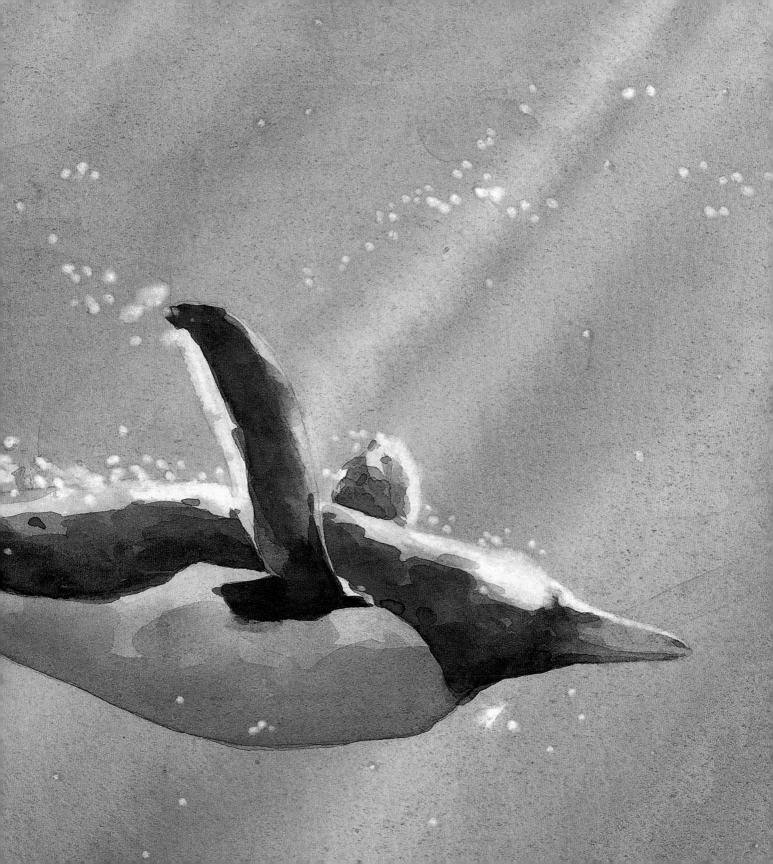

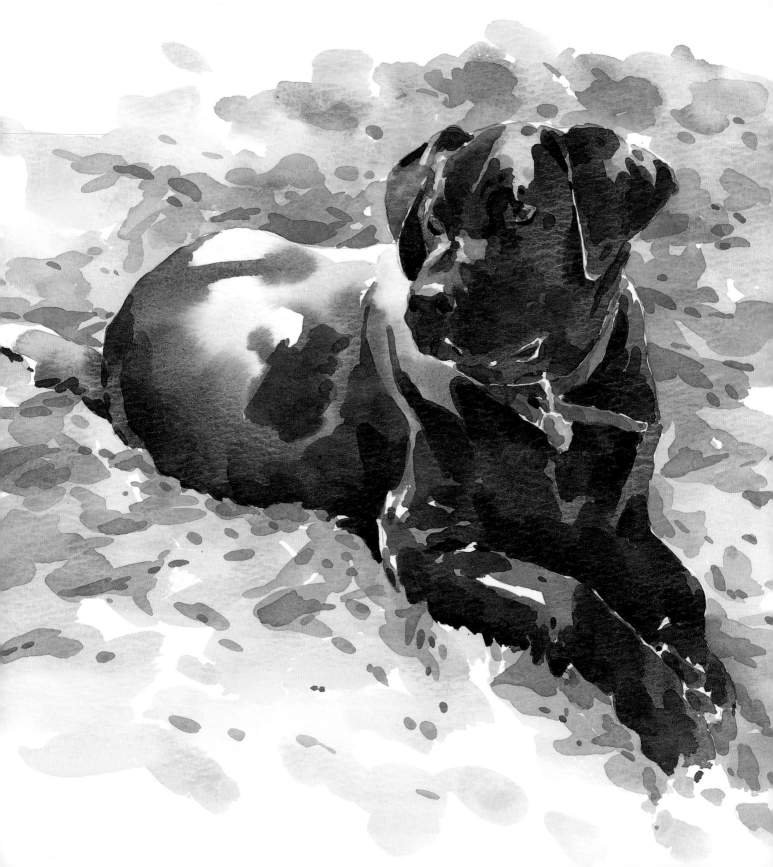

ANIMAL PAINTING WORKBOOK

**LEARN TO PAINT ANIMALS IN WATERCOLOUR
WITH COMPLETE CONFIDENCE AND EASE**

DAVID WEBB

D&C
David and Charles

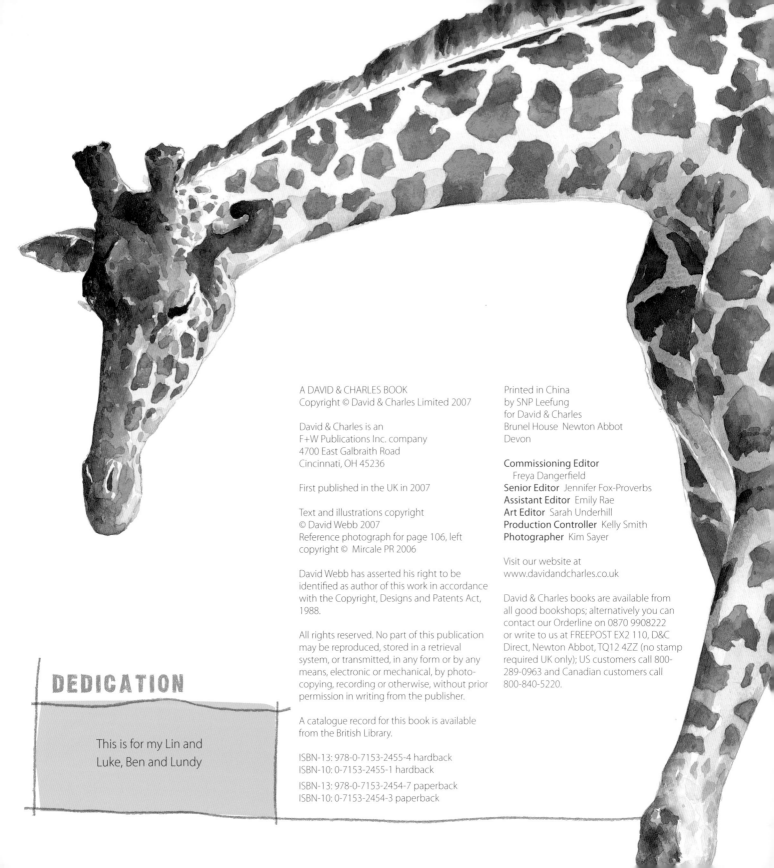

A DAVID & CHARLES BOOK
Copyright © David & Charles Limited 2007

David & Charles is an
F+W Publications Inc. company
4700 East Galbraith Road
Cincinnati, OH 45236

First published in the UK in 2007

Text and illustrations copyright
© David Webb 2007
Reference photograph for page 106, left
copyright © Mircale PR 2006

David Webb has asserted his right to be
identified as author of this work in accordance
with the Copyright, Designs and Patents Act,
1988.

A catalogue record for this book is available
from the British Library.

ISBN-13: 978-0-7153-2455-4 hardback
ISBN-10: 0-7153-2455-1 hardback

ISBN-13: 978-0-7153-2454-7 paperback
ISBN-10: 0-7153-2454-3 paperback

Printed in China
by SNP Leefung
for David & Charles
Brunel House Newton Abbot
Devon

Commissioning Editor
 Freya Dangerfield
Senior Editor Jennifer Fox-Proverbs
Assistant Editor Emily Rae
Art Editor Sarah Underhill
Production Controller Kelly Smith
Photographer Kim Sayer

Visit our website at
www.davidandcharles.co.uk

David & Charles books are available from
all good bookshops; alternatively you can
contact our Orderline on 0870 9908222
or write to us at FREEPOST EX2 110, D&C
Direct, Newton Abbot, TQ12 4ZZ (no stamp
required UK only); US customers call 800-
289-0963 and Canadian customers call
800-840-5220.

DEDICATION

This is for my Lin and
Luke, Ben and Lundy

CONTENTS

INTRODUCTION

Animals have long held a fascination for artists – even the earliest cave dwellers adorned their walls with paintings of wild creatures. It must be said, however, that animals are possibly the most difficult of all subjects to paint and draw.

They certainly don't make it easy for us: some animals will allow you to get within a certain range before retreating, but wild animals are usually viewed from a distance, and most will take flight at the first sight of a human… unless, of course, they're planning to eat us. Tame animals, too, are often not much more cooperative – even animals such as domestic cats, which seem to sleep for hours on end, will suddenly become animated when someone sits down in front of them with a sketchpad. However, none of this matters in the end, and animals and birds remain a very popular subject for artists.

Inquisitive
The curious nature of this ginger cat was achieved with a few loose washes. Details were reserved for the penetrating eyes.

Knowledge

The natural world contains a huge variety of potential subjects. Whichever species you chose to draw or paint, you need to get to know your animal. The world's greatest wildlife artists, regardless of their individual painting styles, all have one thing in common; they study and know their subject. If you have pets, they will provide you with an ideal opportunity for close study. Forget drawing for a moment – just watch the way they move, how their limbs work, how they sit. Try to imagine their skeleton underneath the skin: most mammals, however different they may be from us, possess limbs with joints, which only allow movement in certain ways. It's important to know the limitations of these movements.

For those of us who cannot afford to study exotic creatures in their natural habitat, zoos provide us with the opportunity to study species we might not otherwise get the chance to see. Captive animals offer the artist a closer view and are often seen at rest.

If you are new to animal drawing, using just a sketchpad and pencil is a good start. Your efforts may be hesitant and a bit wooden, but with practise and close observation you will improve.

DAVID WEBB

4

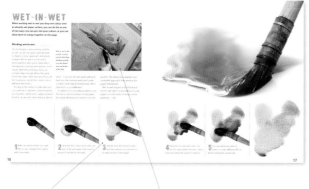

Step-by step sequences explain basic techniques of watercolour painting.

Methods and ways of application are fully illustrated and backed up by text.

Exercises focus on specially chosen teaching points.

Practical how-to advice, tips and tricks are illustrated with sketches, paintings and work in progress.

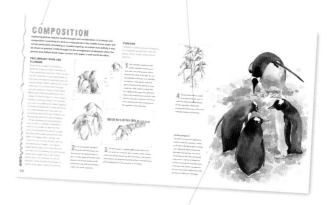

Further finished animal paintings related to the exercise offer more insight into my methods and techniques .

How to use this book

Within these pages you will find plenty of useful advice and tips on the subject of drawing and painting animals.

The book begins with an exploration of some basic watercolour techniques, with pointers on how these can be applied to your animal paintings. The first lesson looks at drawing and measuring proportions, which are important skills regardless of subject matter. Whether you choose to depict animals, ships, buildings or people, a good drawing is the cornerstone of a good painting, so please don't skip this chapter! Subsequent lessons cover progressively more challenging exercises, to help you develop your skills as you work through the book.

Each lesson covers a different subject, and includes a gallery of related paintings. The exercises cover various teaching points such as proportions, contour drawing, textures, features and composition, and each lesson concludes

with a step-by-step demonstration that illustrates the various points covered in the exercises.

I teach a number of classes and workshops, and lessons on painting animals are always popular. Through my lessons, I have come to know the most common problems faced by students, and the solutions to these problems have been incorporated into this book.

Step-by-step ...

Each demonstration starts with the finished animal painting that you can now achieve by following the subsequent step-by-step photographs and text. The transition from original reference image to the watercolour composition is explained, and the paints used are illustrated as colour swatches.

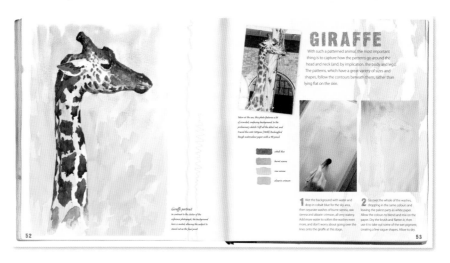

PAINTS

Watercolour paints are available in two forms: tubes and pans. Tubes contain soft colour, which is roughly the consistency of toothpaste. Pans are moist, solid tablets of colour, most often supplied in sets of colours. The quality of either variety is the same, so the choice of which to use is really just a matter of personal preference.

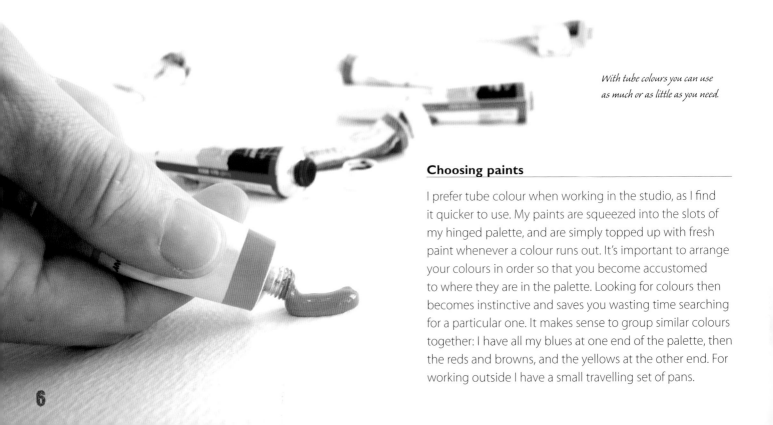

With tube colours you can use as much or as little as you need.

Choosing paints

I prefer tube colour when working in the studio, as I find it quicker to use. My paints are squeezed into the slots of my hinged palette, and are simply topped up with fresh paint whenever a colour runs out. It's important to arrange your colours in order so that you become accustomed to where they are in the palette. Looking for colours then becomes instinctive and saves you wasting time searching for a particular one. It makes sense to group similar colours together: I have all my blues at one end of the palette, then the reds and browns, and the yellows at the other end. For working outside I have a small travelling set of pans.

Types of paints

There are two standards of watercolour paints available to the artist: student colours and artist's colours. Student colours are not quite as strong as artist's colour; they are less expensive, and the colours within the range are usually priced the same. Artist's colours are much more intense than the student variety, and less paint is needed to achieve the desired effect; however, they are more expensive, and colours within the range can vary quite considerably in price.

If you are serious about painting, it's always wise to buy the best you can afford. Artist's colours are definitely better, but if they are beyond your means, make sure that you buy student colours from an established manufacturer. The big companies sell both types, and the student varieties are usually of a good standard. I would, however, avoid the cheap, unknown paints that may be offered at the local discount store; it's far better to buy a few tubes or pans of good quality than a large set of inferior paints.

Basic colour palette

As animals and their surroundings may contain a wide range of colours, it follows that your palette should contain enough colours for all eventualities. However, having a variety doesn't mean that you need to have a great number of colours; quite the opposite, in fact. I like to paint with a fairly limited palette, and prefer to mix as many of my colours as I can. My own palette contains twelve colours at present – of these, about eight are favourites, and these tend to get used more than others. You will see that my list doesn't include any ready-made greens, as I prefer to mix my own.

Pick up another painting book and you'll probably find that the artist's choice of colours is different from mine, or some of them at least. I'm not suggesting that my choice is any better or worse, but it works for me – it took me years of trial and error to compile my own colour palette, and I still change colours from time to time. It would be a boring world if everyone used the same colours; however, whatever your own personal choice, you should have several versions of each of the primary colours: yellow, red and blue.

My basic palette
From left to right above: raw sienna, aureolin, lemon yellow, light red, alizarin crimson, cadmium red pale, raw umber, burnt sienna, ultramarine blue, cerulean blue, cobalt blue, phthalo blue.

You can mix or use tube paints directly at full strength, or dilute them as required.

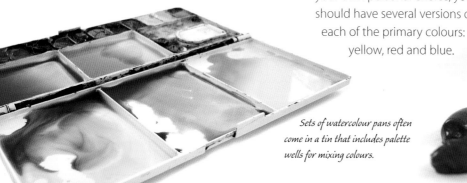

Sets of watercolour pans often come in a tin that includes palette wells for mixing colours.

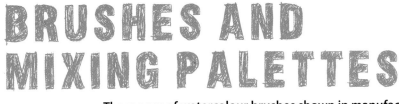

BRUSHES AND MIXING PALETTES

The ranges of watercolour brushes shown in manufacturers' catalogues is huge, and separating what you might use from what you certainly won't can be a costly process. By contrast, you can use a series of ordinary white saucers as mixing palettes, although a purpose-made palette saves time and bother when mixing.

Brushes

I get by with three brushes for animal painting. For most of my work I use a large French-made squirrel mop, size 8 (far left). I normally work on half imperial size paper, (56 x 38cm/22 x 15in) and this brush is capable of covering the entire sheet if I want to do a background wash. I also have a size 4 synthetic brush (centre), which is about half the size, and is useful for areas requiring a little more detail. Lastly, I have a fine rigger (near left), which I only ever use for last-minute details.

Choosing brushes

Brushes for watercolour painting are available in a wide variety of shapes and sizes. To begin with, it is best to start with a traditional round brush, as this is particularly versatile – it can be used to paint large washes, yet its point is also fine enough for adding even very small details. Flat brushes are better suited for painting large washes, although, with practise, they can be quite as adaptable to different uses as round brushes.

When buying brushes, it really is a case of 'you get what you pay for'. You don't actually need many brushes – I always use the biggest brush that I can. A good brush can be used for painting large areas, yet the point should also be fine enough for smaller details. It's far better to have two or three good-quality brushes, than a bumper set of 20 from the local discount art-materials emporium. See left for my three essential brushes.

Types of hair

There is also a choice when it comes to what the brushes are actually made of; once again, price will be a factor when making your choice, though it should not be the only one. A good watercolour brush should be capable of holding plenty of water, and should also return to a point. There are three types of brushes commonly available for watercolour: sable, synthetic and squirrel hair.

Sables are widely accepted as the best brushes for watercolour painting. They possess a good water-holding capacity and are a joy to use. They are also quite springy and readily return to a point. However, they are also the most expensive, and you may be quite taken aback by the price of a large, good quality sable brush.

Synthetic, or manmade, brushes offer a less expensive option. These brushes have really come a long way in recent years and are well worth considering. Their one drawback is that they do not hold quite as much water as a brush made from natural fibres; if, like me, you work quite loosely, then this may be a deciding factor.

Squirrel-hair brushes, often referred to as squirrel-hair mops, have the biggest water-holding capacity of the three, and are excellent for applying washes to large areas of paper. They can be difficult to handle, though, as, compared to springy sables and synthetics, they are quite limp.

So, which ones to use? I use all three! That said, I prefer a squirrel mop for the majority of my paintings, as I paint quite loosely and just love the amount of water they can hold.

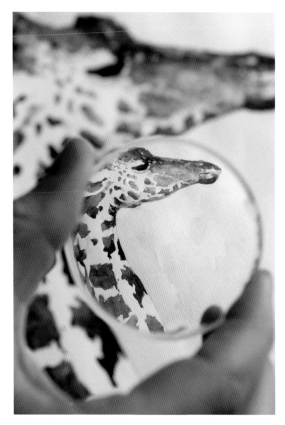

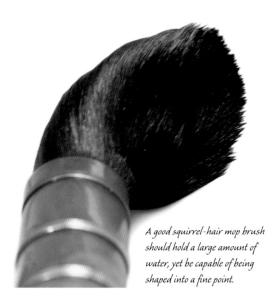

A good squirrel-hair mop brush should hold a large amount of water, yet be capable of being shaped into a fine point.

Mixing palettes

Palettes are available in a range of shapes and sizes, and can be made from plastic, enamel or china. The main thing to consider when choosing a mixing palette is the size of the mixing wells: ideally, there should be five or six large spaces for mixing up your colours.

If you intend to paint outside on location, a plastic palette is a good option, as it is lighter to carry than one made from china. My own tin-and-enamel travelling palette is hinged down the centre; when opened, it reveals colours arranged along one edge and six good-sized mixing wells.

Reducing lens

This has the opposite effect to a magnifying glass, in that it reduces the image. I often use it to view my paintings to chech that proportions are correct. It's like stepping back from a painting to get an overall view – which I also do.

Pipette

I use a small plastic pipette to add water to the palette when diluting or mixing colours; this allows me to drop in a very small amount of water and thus build up the consistency I want.

PAPER, SKETCHBOOKS AND ACCESSORIES

If you are simply drawing you can sketch on almost any kind of paper, from purpose-made spiral-bound pads to the backs of old envelopes. But when it comes to watercolour painting, there are some more choices to be made.

Types of watercolour paper

Watercolour paper is made in three types of surface: hot-pressed (smooth), cold-pressed or Not (medium), and rough. Hot-pressed is usually reserved for pen work and fine detail. It is not quite so easy to paint on in loose washes as the other two types, however, as the paint tends to slide over the paper and settle in pools.

Not and rough are more often used for pure watercolour painting. Not (standing for 'not hot-pressed') paper has a slightly rough surface, and the rough one is more textured still. I tend to use rough for most of my work, as I like the texture. It is also the best surface for drybrush technique; for a little more detail, I use the Not surface.

Weights of watercolour paper

Paper is manufactured in varying weights. The heavier the paper, the less likely it is to buckle when watercolour is applied to it.

The weight of the paper refers to the weight of a ream and is written in grammes (gsm) or pounds (lb) per square metre. A small pad of 190gsm (90lb) will take a light wash without buckling; however, for most watercolour painting a weight of at least 300gsm (140lb) is preferable. If you intend to really soak your paper with paint, you either need to stretch it or use a heavier paper – I find that 300gsm (140lb) is usually quite adequate, but if I'm working on a painting that involves some large washes I move up to a sheet of 425gsm (200lb).

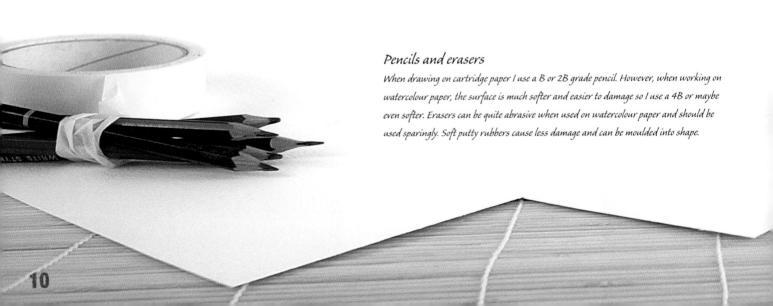

Pencils and erasers

When drawing on cartridge paper I use a B or 2B grade pencil. However, when working on watercolour paper, the surface is much softer and easier to damage so I use a 4B or maybe even softer. Erasers can be quite abrasive when used on watercolour paper and should be used sparingly. Soft putty rubbers cause less damage and can be moulded into shape.

Buying watercolour paper

Watercolour paper can be bought in pads, blocks or loose sheets. Pads are quite convenient for painting out of doors, especially the spiral-bound variety, and a few bulldog clips will help keep the pages flat on a windy day.

Watercolour blocks are also very good for outdoor work. These are like pads but each page is gummed around all four edges, apart from a small space on one side. The advantage of the block is that the page will not flap about in a strong breeze, and it tends not to buckle either, as the paper is stretched flat. When you have completed your painting you simply insert a knife into the space and cut through the gum around the outside. The underlying page is then revealed and is ready to paint on. The only slight drawback, when working outdoors, is that you then need something in which to keep your finished paintings.

When working in the studio I buy my paper in loose sheets and cut these to the size I want. I then fix them to a board with masking tape, which I attach all the way round the edge of the sheet.

Watercolour papers with a coloured tint are also available. Normally you would rely on the whiteness of the paper for highlights, but when painting on tinted paper, you will have to use white paint, otherwise known as body colour.

Paper for sketching

If I'm working in the studio, and a bird lands in the garden within sketching range, I'll grab whatever is nearest to hand. Most kinds of paper surface will readily accept a pencil line; however, pads of cartridge paper are probably the best choice. Spiral-bound pads are ideal, as you can hold them with one hand and sketch with the other.

Sloping bases

If you like to work on a tilted board, cut a a couple of pieces of plywood to the size of your board (top), slot them together to fit into an 'X' (middle), and rest the board on them (bottom).

Sketchbooks

Hardbound sketchbooks are by far the best type to buy, as the binding will protect all your sketches and drawings.

FLAT WASH

A flat wash is one of the most basic techniques used in watercolour. It can cover the whole page, particularly if you want a background tint for your painting, or it can cover a relatively small area.

Why choose a flat wash?

This is a useful technique to master as it can set the background tone for a painting and can be used where you want a flat area of colour. I may use it as a first step in painting a large animal, such as an elephant, gradually building the painting in several washes, from light to dark.

Laying a flat wash

There is a right way of laying a wash. First, you must dilute some colour in your palette. It is important to mix up enough colour to lay the wash in one go – if you don't make enough, you will have to stop and mix up some more, and while you

are doing this, the paint that you have already applied to the paper will be drying. In addition, when you apply the new colour, it is unlikely that this will be the exact same colour as the original. Before you start painting, ensure that your painting board is propped at a slightly raised angle, so that it slopes down towards you (see page 11). This is to help the colour flow gently down the page; if the board is laid flat, it is likely that the paint will just sit in pools and dry unevenly.

Now dip your brush into the dilute paint, making sure that it takes up plenty of colour, then paint a horizontal stroke at

the top of your page, from left to right if you are right-handed, and vice versa if you are left-handed. You'll see that a long bead of paint will collect along the bottom edge of the paint stroke. Return your brush to the palette to soak up some more colour. Paint a second stroke directly under the first one, making sure that the brush touches the bottom edge of the previous one; you will find that the bead of paint will flow down into the paint you have just applied and, again, will sit along the bottom edge of the new brushstroke. It is then just a case of repeating this action until you have covered the entire area of your flat wash.

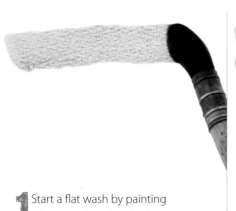

1 Start a flat wash by painting a horizontal stroke of colour along the top of a piece of paper – the movement of the brush should be even and smooth.

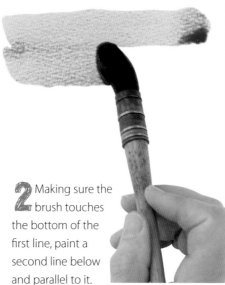

2 Making sure the brush touches the bottom of the first line, paint a second line below and parallel to it.

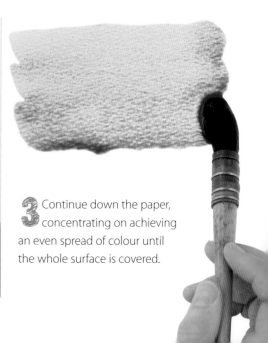

3 Continue down the paper, concentrating on achieving an even spread of colour until the whole surface is covered.

GRADED WASH

A graded wash differs slightly from the flat wash, in that the colour varies in intensity from dark at the top to lighter at the bottom. This technique is a little trickier than the flat wash, but, with practise, you should be able to master it fairly quickly.

Why choose a graded wash?

I often use a graded wash when I'm painting a sky, where I may want a gradual change in tone from dark to light, and when painting areas of calm water. It can be applied to animals too, where a subject may be lit from above and a subtle change of tone is required where the animal's body enters the shade.

Laying a graded wash

Lay your first stroke of colour, as described opposite. This time, however, instead of reloading your brush with colour, dip it once into a jar of clean water. The paint on your brush has now been diluted. Now apply your second brushstroke, as before, then dip it once into the water jar again, and paint the third paint stroke. Your wash will become progressively paler in tone as you continue.

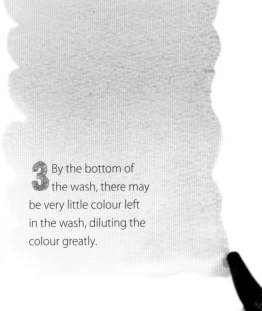

Seal underwater
The background was achieved with a graded wash: I turned the paper upside down and started with a mix of phthalo blue and raw sienna, gradually diluting the brushstrokes as I worked down the page. Once dry, I righted the painting so the darkest area was at the bottom, to indicate deeper water, and painted the seal.

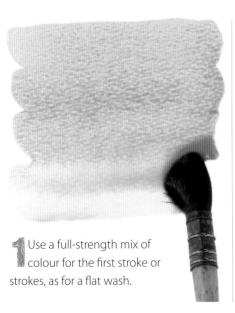

1 Use a full-strength mix of colour for the first stroke or strokes, as for a flat wash.

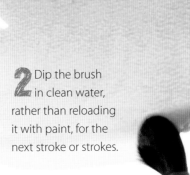

2 Dip the brush in clean water, rather than reloading it with paint, for the next stroke or strokes.

3 By the bottom of the wash, there may be very little colour left in the wash, diluting the colour greatly.

VARIED WASH

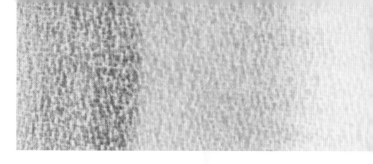

As its name suggests, a varied wash uses more than one colour – for example, skies may contain several colours, ranging from blues and greys to reds and yellows. A varied wash is a useful method of portraying soft, gradual changes of colour.

Laying a varied wash

As with the flat wash, it is important to have sufficient quantities of all your chosen colours already mixed and ready for use before you begin. You can wet your paper first, if you prefer, as this can help the colours to blend softly; however, it is possible to work on dry paper, as shown on the previous pages.

Why choose a varied wash?

Using a varied wash ensures a natural appearance while emphasizing the different contours and shadows, as seen here on the Herd of Cows. The technique also enables you to make subtle changes from warm to cool areas of colour.

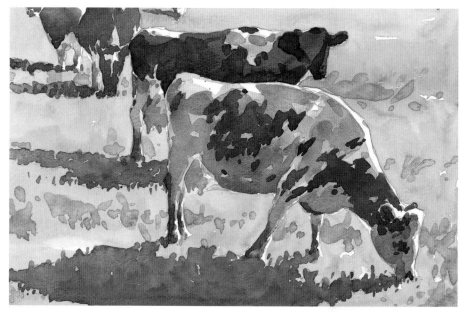

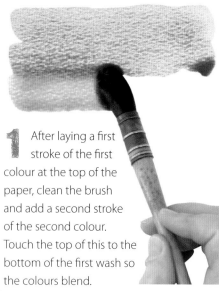

1 After laying a first stroke of the first colour at the top of the paper, clean the brush and add a second stroke of the second colour. Touch the top of this to the bottom of the first wash so the colours blend.

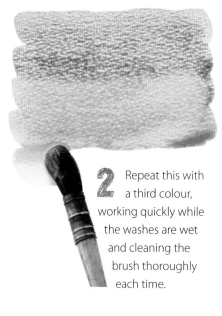

2 Repeat this with a third colour, working quickly while the washes are wet and cleaning the brush thoroughly each time.

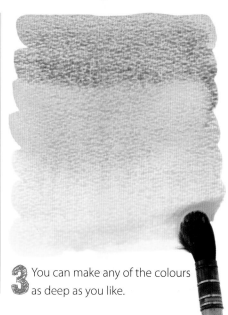

3 You can make any of the colours as deep as you like.

Working with a varied wash

In this sequence from the Herd of Cows demonstration on page 76, I use varied washes to place the shadows on the cows.

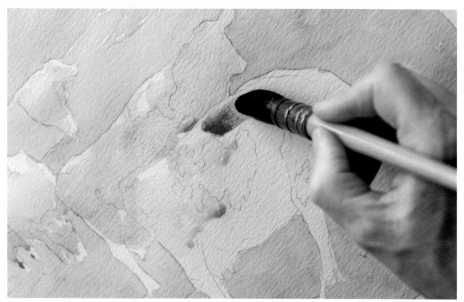

1 While the red wash is still wet on the left I drop in a wash of blue, equally diluted...

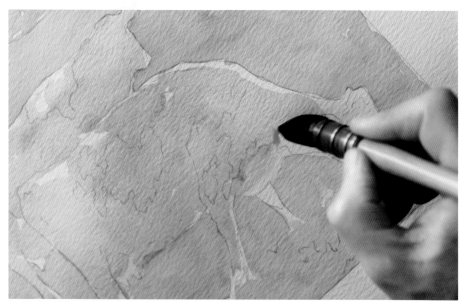

2 ... and then go back to the red to make a varied effect as I go down the cow's body.

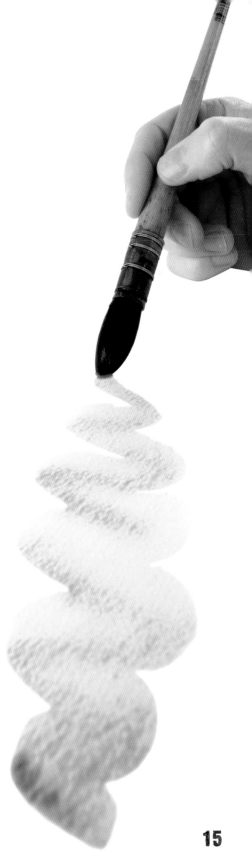

WET-IN-WET

When working wet-in-wet you drop wet colour onto an already wet paper surface; you can do this in one of two ways: you can pre-mix your colours, or you can allow them to merge together on the page.

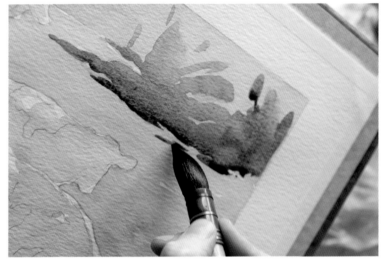

Working wet-in-wet

This technique is very exciting, and the results can also be quite unpredictable. It requires a loose approach and plenty of water. Wet-in-wet is most useful when painting skies, particularly when attempting to portray atmospheric storm clouds. With this technique there are no hard edges except where the paint meets the edge of the wet area. If you tilt the board, you can let the colours run in different directions.

As long as the surface is quite wet you can continue to add wet colour. However, you must be careful not to apply a loaded brush to an area of colour that has almost

Wet-in-wet is also good for creating varied, interesting backdrops quickly, as in the distant trees and bushes of this field.

dried – if you do, the wet paint will push back into the existing wash and create a visible, hard-edged drying mark, often referred to as a 'cauliflower'.

In addition, it is actually possible to use the wet-in-wet technique on dry paper by simply allowing one wash to run into

another. This allows for a slightly more controlled approach than wetting the paper beforehand.

Wet-in-wet requires a lot of trial and error to get right. Try practising on scrap paper or on the backs of unsuccessful paintings – I do!

1 Make up washes before you start. Wet an area of paper thoroughly with clean water.

2 Drop the first colour wash onto one part of the wet paper and move it around. Don't fill the wet area.

3 Quickly clean the brush in water and then add the second wash to an adjacent area of wet paper.

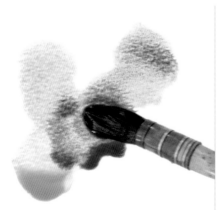

4 Bring the second wash over onto the first wash where the two colours meet, and allow the washes to blend.

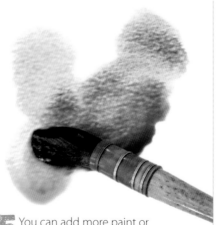

5 You can add more paint or water to create different effects before letting the washes dry.

WET-ON-DRY

Applying watercolour to dry paper gives you a lot more control than the wet-in-wet technique, as unlike applying colour to wet paper, with wet-on-dry the paint tends to stay where you put it.

Using wet-on-dry

The wet-on-dry technique also gives you nice sharp edges and is the best method of applying colour for portraying details. The flat, graded and varied washes demonstrated on the previous pages are examples of painting wet-on-dry.

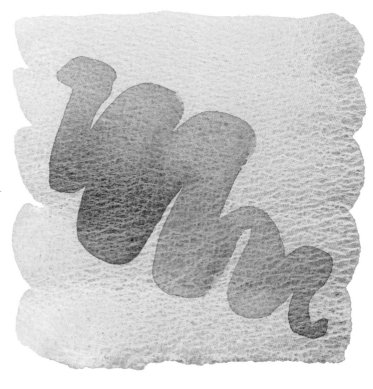

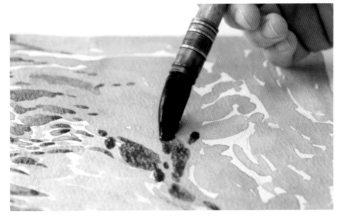

The hard edges obtained by painting wet-on-dry can provide added depth to your work; here I use the technique for the sea in the Seals project on page 102.

1 Unlike wet-in-wet painting, make sure the first wash is completely dry before applying the second colour on top of it.

2 As with all watercolour painting, work boldly and quickly to make confident, loose brushstrokes in the first instance.

3 You can use the hard edges of the second colour to good effect, and vary the amount of paint that goes onto the surface.

DRYBRUSH

This method of applying paint to the paper produces a characteristic sparkling appearance.
Drybrush is an effective method of portraying the shimmering highlights on the surface of water,
for example, and can also be used to describe bark on trees or the rough surface of rocks.

Painting drybrush

To achieve the effect, most of the surplus water is removed from the brush, either by flicking it off or soaking up the excess with a kitchen towel. The brush is then moved swiftly across the paper, so that the hairs, or fibres, merely skim the paper surface. If done correctly, the paint applies itself to the raised bumps, but does not reach the hollows; you will find that the rougher the surface of the paper, the easier it is to get good results.

Used sparingly, in conjunction with a variety of other techniques, drybrush can be very effective. However, try to avoid overusing it. I tend to use several methods in any one painting, as this makes the process more interesting.

Drybrush requires a little practice to get just right. Save scraps of watercolour paper for the purpose of trying out any new techniques. Once you are confident, you can then work on an actual painting.

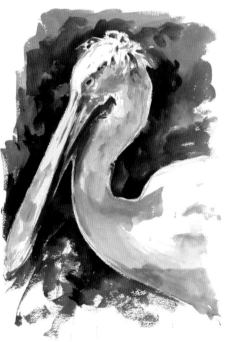

Sunlit pelican
The negative shape of the background was painted first, leaving the bird's outline. The dark brown brushstrokes towards the bottom of the painting were made using the drybrush technique.

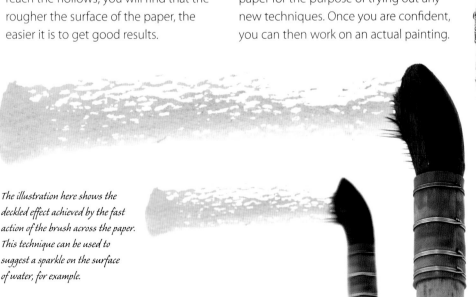

The illustration here shows the deckled effect achieved by the fast action of the brush across the paper. This technique can be used to suggest a sparkle on the surface of water, for example.

COLOUR AND COLOUR MIXING

By their very nature, watercolour paintings are transparent – thin washes of colour painted over a white surface appear to glow. As mentioned previously, you can achieve quite a range of colours with a limited palette. Try some of the exercises on this page and experiment – animals come in all sorts of colours so the greater your repertoire the better.

Colour dilution (right)

The three columns show what happens when you add water to tube colours. I started with fairly strong mixes of each colour at the top and diluted them gradually, painting a fresh strip below each time I added more water.

Using two colours

Unless I'm mixing colours wet-in-wet, where anything goes (see page 16), I try to restrict my colour mixes to just two colours. Occasionally I may introduce a third – but carefully, so I don't end up with a muddy puddle in the mixing well. Some pigments are opaque, but I prefer to use transparent colours only.

When mixing two colours together in your palette, it makes sense to add the darker colour to the lighter one; for example, if you want to make a light green you should add blue to yellow in small amounts. This may seem obvious, but if you start with the blue, you will have to get through a bucketful of yellow before you achieve a light green.

Colour combinations

I use several colour-mixing combinations. These are all mixed from two colours, and all the colours used are from my own palette. I use several blues and yellows, which give me almost limitless varieties of greens – you will be surprised at the number of different shades of green you can get from just two colours.

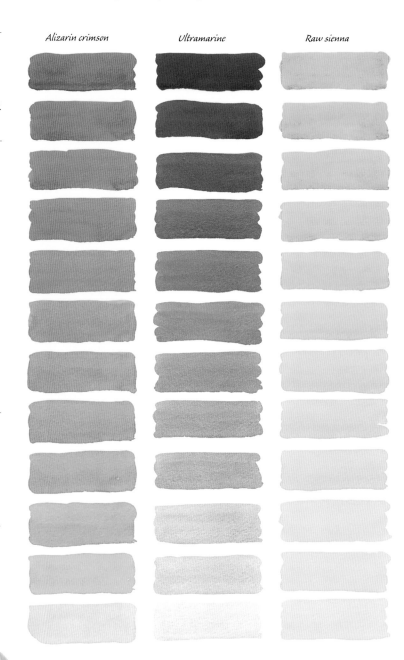

Alizarin crimson *Ultramarine* *Raw sienna*

Colour-mixing exercise

First, add some water to one of the mixing wells in your palette, then add raw sienna to the well and mix it thoroughly until the colour is completely dissolved.

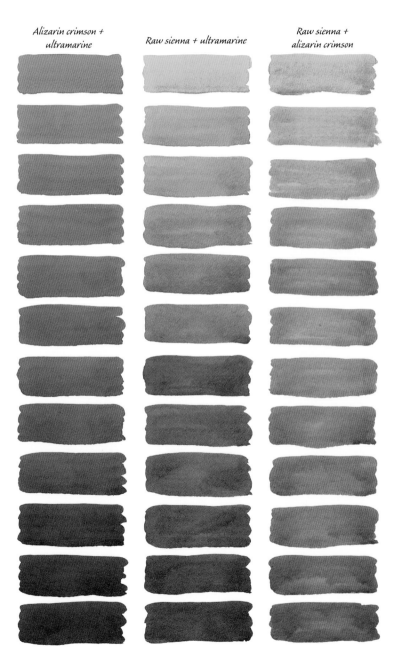

Alizarin crimson + ultramarine

Raw sienna + ultramarine

Raw sienna + alizarin crimson

This is important: if you don't mix properly, small bits of neat colour may appear as streaks when you apply a brushstroke to the paper.

Now paint a strip of colour about 5cm (2in) across at the top of a sheet of paper. Rinse off your brush in your water jar and shake off any excess water. Now add a very small amount of ultramarine to the same mixing well, again diluting it thoroughly. Now paint another strip of colour directly underneath the first. You should find that there is a slight colour shift towards green.

Repeat the process about a dozen times. You should end up with a range of colours, from yellows and yellow-greens through to blue-greens, all of which are quite natural-looking and could quite reasonably be used in a landscape painting. If you find that the shift is too drastic after the first few brushstrokes, you have added too much ultramarine too soon. Carry on with this until you get the hang of the method.

Further exercises

Try the same exercise with these pairs of colours to start a palette of shades useful for animal painting:

- **Burnt sienna + phthalo blue** produces a range of dark greens suitable for painting fir trees and ivy.
- **Lemon yellow + ultramarine** makes a brighter range of greens, suitable for foliage and also some bird species.
- **Raw sienna + phthalo blue** provides some natural-looking greens, which are useful for background foliage.
- **Alizarin crimson + ultramarine** produces a variety of purple shades, most useful in areas of shadow.
- **Raw sienna + alizarin crimson** gives a range of warm oranges, which can be useful when painting tiger fur.
- **Burnt sienna + ultramarine** makes a very useful range of warm and cool greys. Add more burnt sienna for warmth or more ultramarine for coolness. This combination is ideal for portraying animals with black fur, as various shades can be used to show the animal in bright or dull lighting conditions.

When you have done them satisfactorily, file the colour-mixing sheets, as it can be useful to refer to them later.

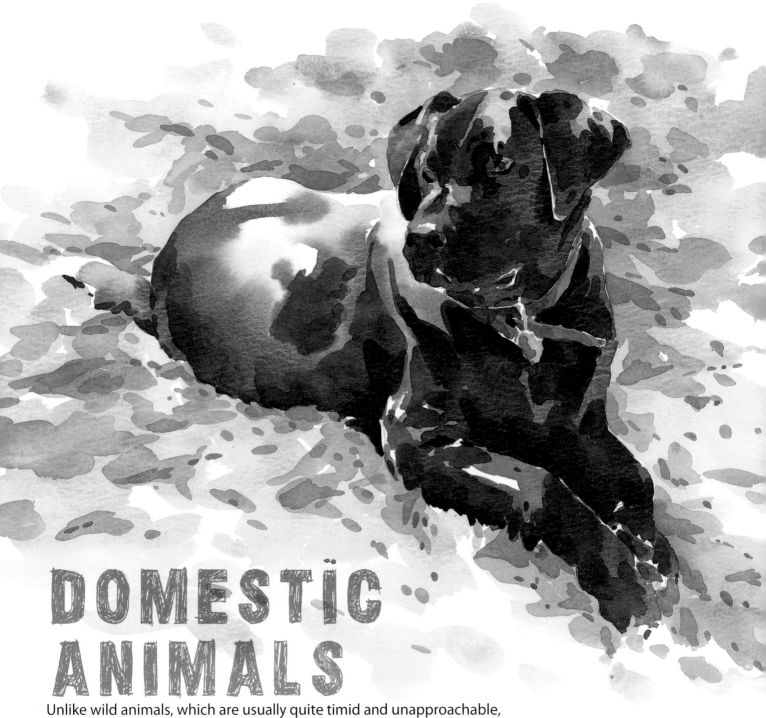

DOMESTIC ANIMALS

Unlike wild animals, which are usually quite timid and unapproachable, domestic animals are, in the main, quite docile and co-operative. Sketch your pets as often as you can. Begin with sleeping subjects as, obviously, they are easier to draw when they are not moving. Once you have gained some confidence, you can then try sketching some action poses.

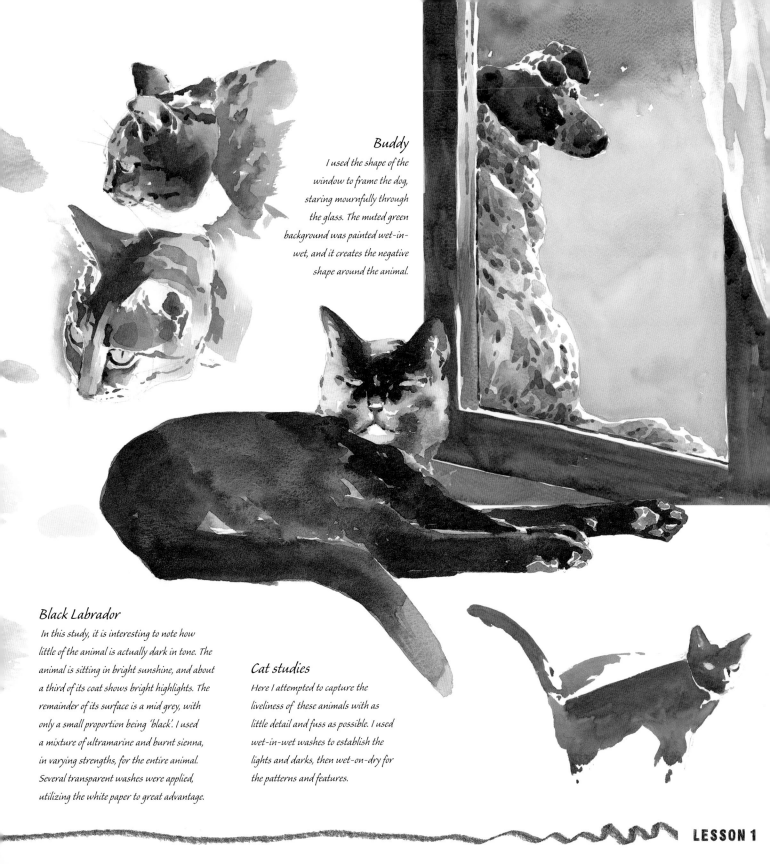

Buddy

I used the shape of the window to frame the dog, staring mournfully through the glass. The muted green background was painted wet-in-wet, and it creates the negative shape around the animal.

Black Labrador

In this study, it is interesting to note how little of the animal is actually dark in tone. The animal is sitting in bright sunshine, and about a third of its coat shows bright highlights. The remainder of its surface is a mid grey, with only a small proportion being 'black'. I used a mixture of ultramarine and burnt sienna, in varying strengths, for the entire animal. Several transparent washes were applied, utilizing the white paper to great advantage.

Cat studies

Here I attempted to capture the liveliness of these animals with as little detail and fuss as possible. I used wet-in-wet washes to establish the lights and darks, then wet-on-dry for the patterns and features.

CONTOUR DRAWING

Having examined colours, it's time to look at one of the the most important parts of painting – drawing. If you want to draw any animal, from pets to wild beasts, you need to be able to sketch freely, quickly and accurately.

GETTING STARTED

Drawing is as much about seeing as it is about making physical marks on your paper. Contour drawing is a great way of loosening up and testing your powers of observation at the same time. It is an essential technique for drawing animals, especially from life.

Anyone can be taught to draw, but – here's the boring bit – it takes practice. I've been drawing from a very early age; perhaps the 'gift' is having the aptitude and the enthusiasm to keep at it. I'd love to be able to play the guitar like Jimi Hendrix. Now, he was gifted, wasn't he? But I know there's little chance of me getting even remotely close if I only play the guitar once a month.

Newcomers to drawing tend to be very rigid and hesitant when making marks on the paper, using just their wrist to move the pencil. You will find that you have much more freedom of movement if you use your whole arm. Have a go at the contour exercise described opposite after reading the tips shown with each of the illustrations here.

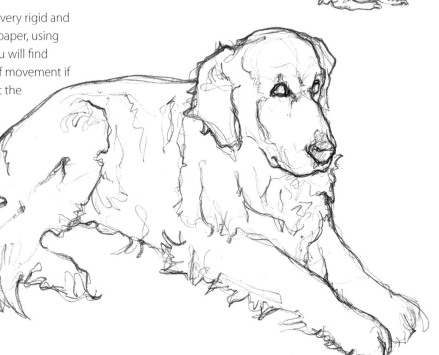

Rocky the rooster
- *It is always useful to look out for angles and repeated shapes.*
- *The line of the back of the neck of this cockerel is about 45 degrees from the vertical.*
- *If you look closely, you can see that the line of the breast, leading to the stomach, is also 45 degrees.*
- *The line from the tail down to the legs is almost a mirror image of this line.*

Golden retriever
- *I begin a contour drawing by starting with the eyes and working out from there.*
- *Long hair can be distracting. Try to concentrate on the animal's actual shape rather than the details, as once you have that, you can then suggest the long fur with a few lines.*

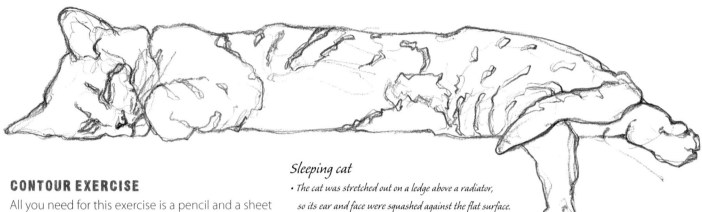

CONTOUR EXERCISE

All you need for this exercise is a pencil and a sheet of paper. To begin with, it might be easier if you use a photograph for reference. Start by placing your pencil onto the surface of the drawing paper. Now take a moment to look at your subject, paying special attention to the outline – try to ignore fur and texture, it is the outline that is important here.

Making the marks

Keeping your pencil on the paper, imagine that the pencil is tracing the outline of the animal. For example, if you are drawing a dog, find a place at which to start, say, the ear.

As you study your subject, move the pencil across the paper. Resist the urge to lift the pencil off the paper: it doesn't matter if there are a few stray lines, as this exercise is all about observation. Keep your eyes on the subject as much as possible, with only the occasional glance at the drawing in front of you, move the pencil quite quickly and do not remove it from the paper until you have finished.

Using contour drawing

This is a very good technique to use when drawing animals from life. Try not to expect great results first time. These drawings shouldn't take very long; the more you do, the easier it gets, and with practice you will be able to sketch your pet with hardly a glance at the paper.

Sleeping cat
- *The cat was stretched out on a ledge above a radiator, so its ear and face were squashed against the flat surface.*
- *The line is broken by the two back legs overhanging the ledge.*
- *The stripes and spots follow the curves of the body.*

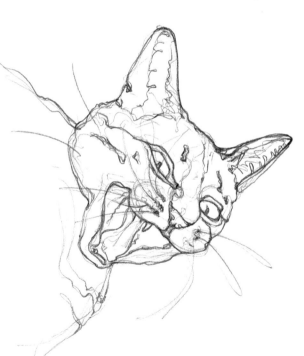

Yawning cat
- *This was a sketch from a photograph, as it would be difficult to capture this expression in such detail when drawing from life.*
- *At first glance this pose might appear quite difficult. However, if you look for familiar shapes and study the proportions it can be broken down into manageable shapes: the ears and open mouth are very clearly triangular.*

PROPORTIONS

When drawing any animal, it is important to ensure that you get your model's proportions right – for example, if you are drawing a cat, you need to make sure that the legs, body and head all appear to be the right scale in relation to each other. Many people have problems with this, but measuring proportions is not as difficult as it may first appear. It all boils down to measurements and angles.

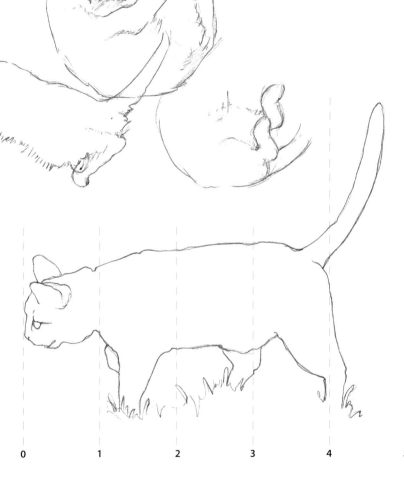

Cat pencil sketches

This cat was fast asleep when I started sketching, but then decided to change poses and have a stretch. I focused on getting the outline and proportions correct, and had time to do a little shading on the head before he strutted out of the room.

SETTING THE MEASUREMENTS

It is quite useful to use one particular feature, such as the head, as a standard measurement for the rest of the drawing. Take a moment to study the drawing, right, of a cat walking through grass.

❧ The scale shown underneath represents how many 'head lengths' the animal is.

❧ The tip of the cat's nose lines up with the '0' mark shown underneath.

❧ The '1' mark is in line with the furrow where the cat's collar would be.

❧ From this, you can see that the distance from 0 to 1 is one head length.

❧ The remaining numbers in the scale, going up to 5, are each the same length as the original head length as desribed above.

❧ A line down from the tip of the tail falls roughly halfway between the 4 and 5.

❧ It follows, then, that the cat is 4½ head lengths long from nose to tail.

| 0 | 1 | 2 | 3 | 4 | 5 |

Cat proportions

The final painting can be seen on page 100 – note that in this drawing I have kept the tail straight, the better to illustrate the method of setting the measurements using the head, as described above.

POSITIONING LIMBS

You can also use the scale shown opposite to determine the position of the limbs. The example shows that the nearest back leg, for instance, falls exactly above the '4' mark, which makes it 4 lengths from the tip of the nose. The right-hand edge of the nearest front leg is about 1½ lengths along. Obviously, it follows that you can also use this method for determining the height of your animal. That's all there is to it, really. Once you have grasped this concept and remember to use it, you will find that your drawings will be in proportion, and by practising this method it will become second nature to you. I automatically use this technique when I'm drawing: I don't necessarily draw a scale, but I always assess the distances and lengths in terms of the length of the animal's head. This applies whether I'm using a photo for reference or drawing from life, and is applicable to any subject, from still life to landscape.

ANGLES

Angles are another important consideration. In the drawing opposite, the left-hand edge of the nearest back leg is at an angle of about 45 degrees. If you find it difficult to gauge an angle, try holding your pencil in front of you so that the edge of your subject is aligned with the edge of the pencil. Then, without changing the angle, move your pencil down to your paper to see where the angle should lie on your drawing. If you employ both these techniques, your drawing skills should improve quite rapidly.

SKELETONS

An animal's skeleton, like our own, possesses joints that will allow movement in certain directions. A hinge joint, for example the knee or elbow, permits the limb to move backwards and forwards, and that is all. A ball and socket joint, like the shoulder or hip, allows movement in a much wider area. These facts must be remembered when drawing, as to portray the limbs doing anything other than they are capable of would be obviously wrong.

Cat skeleton

It's worth noting how similar the cat skeleton is to a human's – certain limbs may be longer or shorter than ours, but the overall structure is very much the same.

1. Skull 2. Jaw 3. Scapula (shoulder blade)
4. Ribs 5. Spine 6. Pelvis 7. Tail
8. Humerus – ball and socket joint
9. Radius and ulna – hinge joint (elbow)
10. Femur – ball and socket joint
11. Fibula and tibia – hinge joint (knee)
12. Ankle

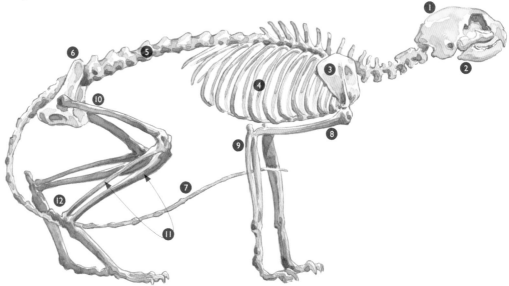

WORKING FROM PHOTOS

There is some controversy about artists using photos as a source of reference. Many purists eschew the use of them in favour of working solely from life (and some say they don't when they do). I think that if you're trying to create an accurate portrayal of an animal on paper, you should use every bit of reference you can get your hands on!

USING A CAMERA

I sketch from life whenever I can, but I also carry a camera. Reliance on photos alone, though, will result in flat and unconvincing paintings. We have two eyes, which give us a three-dimensional view, and the camera only has one. Additionally, a photograph can only present you with a static view: I've taken many photographs and I have several that would make very strange paintings indeed, because I managed to capture the animal in a momentary strange pose – if you've ever taken photos of people at a party, you'll know what I mean! On the other hand, if you are sketching from life you get the opportunity to study your subject from several angles, and you can actually move around it if an object obscures it.

In this study (above) the rabbit was stretched out, and a couple of paws were visible. I always pay special attention to the direction of the light source – here, a window to the left.

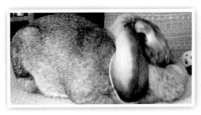 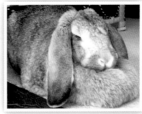

In this side view (below) the limbs aren't visible. However, you can make out the shape of the leg bones beneath the skin. I always try to visualize the skeleton of the animal when I'm drawing, even though I can't see it.

Lulu was not very animated when I took the photos for these paintings, so I concentrated on capturing some interesting 'resting' poses (below).

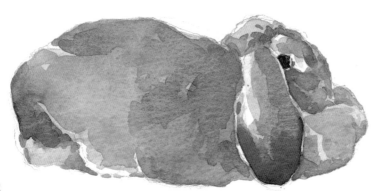 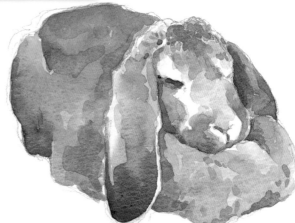

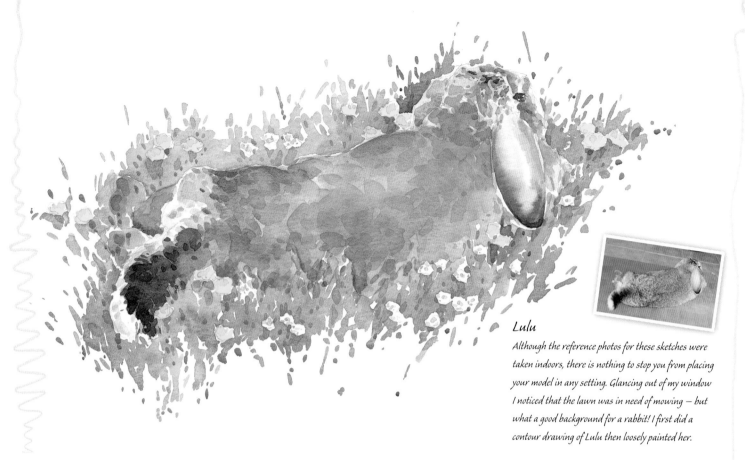

Lulu

Although the reference photos for these sketches were taken indoors, there is nothing to stop you from placing your model in any setting. Glancing out of my window I noticed that the lawn was in need of mowing – but what a good background for a rabbit! I first did a contour drawing of Lulu then loosely painted her.

TAKING PHOTOS

If you do use photographs, I advise you to take your own wherever possible, and to take as many as you can. If you are taking photos of your pets, use natural light whenever you can, as this gives a much more pleasing effect. Flash tends to eliminate the more interesting shadows, but often leaves you with a harsh black one around the edge of your subject.

USING PHOTOS AS REFERENCES

I use a reference photo as a sketch: it is a useful tool, but I do not copy it slavishly. As you will notice from the pictures in this book, my paintings are quite loose, and I avoid including any obtrusive or unnecessary detail. If you're sitting in your studio, it is easy to get carried away and paint every feather, whisker or scale. However, if you were sketching from life it is unlikely you would get the chance to do this, as your model would not be so obliging. I bear this in mind when I work from photos: when drawing the outline, I try to keep the drawing to a minimum, as I don't want to end up just filling in the colours. I like to do as much of the work as I can with the brush.

SHADOWS

One of the drawbacks of working from photos is that the colours are not always true, especially in areas of shadow. This is particularly noticeable in photos taken in strong sunlight. Camera exposure systems usually take an average reading, and shadow areas often appear as solid black. If you were to paint shadows as you see them in a photo, they would look ugly and unrealistic. It pays to take careful notes at the photography stage; you can refer to these later when you have your pictures in front of you.

In this slightly more animated pose we can see a little more of the face. Again, details were kept to a minimum and the colours were washed in quickly and loosely.

29

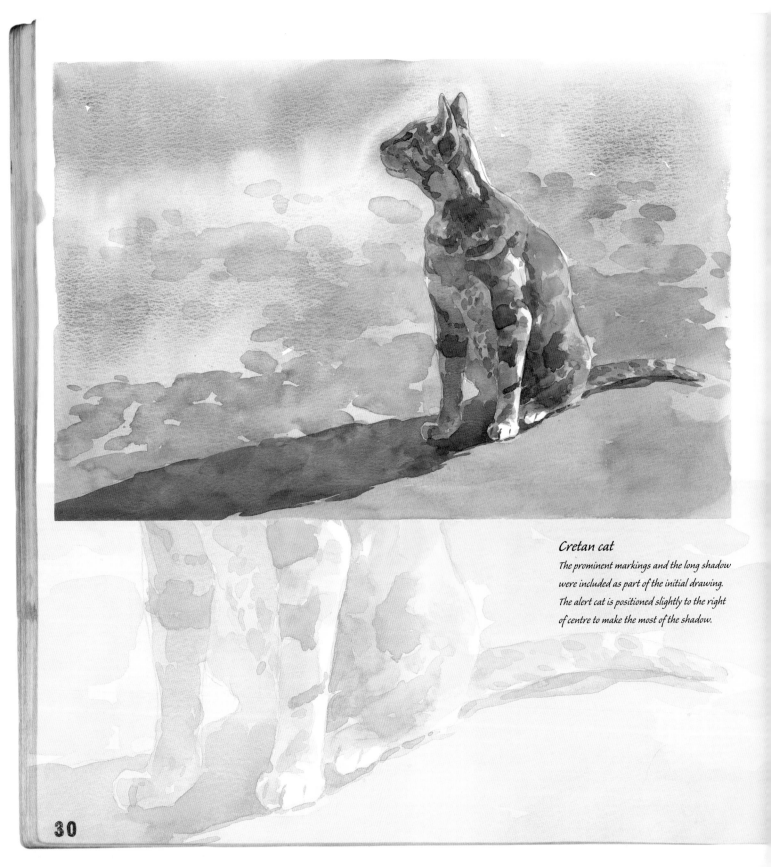

Cretan cat

The prominent markings and the long shadow
were included as part of the initial drawing.
The alert cat is positioned slightly to the right
of centre to make the most of the shadow.

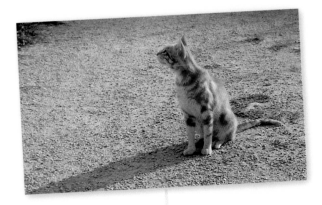

The sun was setting when I took this photo, which is why this rather skinny cat casts such a long shadow. I began by sketching an outline of the animal onto the watercolour paper, ensuring that I got the position of the patterned fur just right.

CAT

Although most of us think that going abroad for a holiday will put us in contact with animals we don't see at home, except in zoos, we're just as likely to encounter domestic pets when away – I met, and was befriended by this cat on holiday in Crete. Because pets and domesticated animals are used to humans being around, they can be sketched and photographed in relaxed poses.

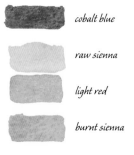

cobalt blue

raw sienna

light red

burnt sienna

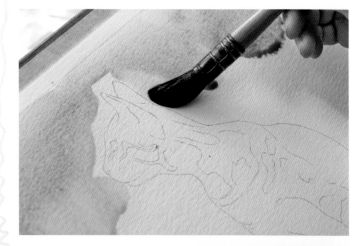

1 Start by filling in the background: drop in a very watery wash of light red, then quickly add a wash of cobalt blue and then some raw sienna below this, blending into it. Use light red and raw sienna for the parts of the cat in shadow, and use raw sienna on the part of the head caught by the sunshine.

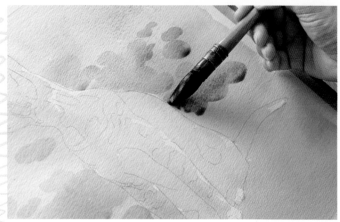

2 To suggest some texture in the vague background, dab on watery washes of cobalt blue and light red on a level with the head, and work these down the paper. Work around the cat, leaving it as a negative shape, and add more cobalt blue for the cooler areas near the cast shadow, and raw sienna for the warmer parts of the ground. Allow to dry.

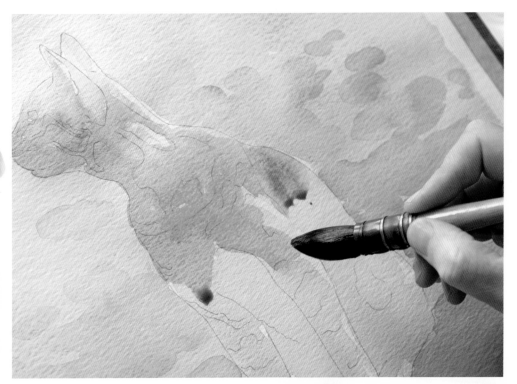

3 Start the cat with cobalt blue on the nose, then work all the colours, now including burnt sienna, down the body wet into wet, blending them on the paper. Don't try to fill the entire space – leave some underwashes and white paper still showing.

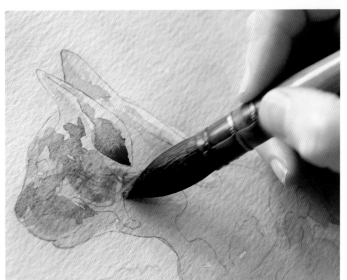

4 Paint in the strong shadows on the cat with cobalt blue, including the shadows on and under the tail. Allow these washes to dry before putting in some stronger mixes to show the contours on the head and body.

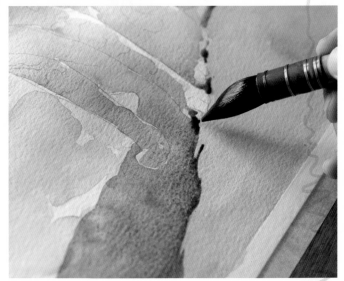

5 When adding the cast shadow, note how this flows down from the body, obscuring the further rear foot. Apply first light red and then cobalt blue, both mixing and blending the colours on the paper and working wet on dry. Leave small white lines to define the forepaws.

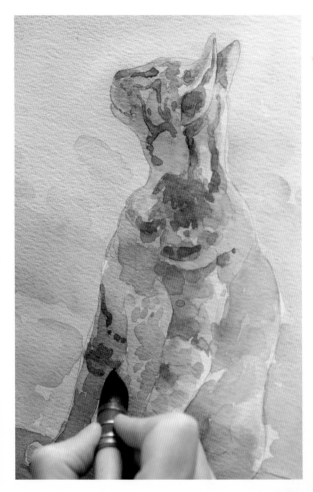

7 Go back to burnt sienna for the near ear and the markings on the back of the neck, and work down to increase the strength of colour on the body. Mix burnt sienna and cobalt blue for the markings on the front legs, and add more cobalt blue for the shadows on the body behind these legs, which throw the white patches forwards in the painting.

6 Build up the markings with burnt sienna in the lighter areas, adding definition and refining the contours. Mix light red and cobalt blue for the markings in shadow, and add more cobalt blue for the cool shadows between the ears. Use the tip of the brush for the finer markings, and to put in the eye and mouth line with a dark version of the same mix.

8 Use the cobalt and light red mixes for the remaining shadow areas, softening the edges with a damp, clean brush. To finish, use the brush tip to put in the toes on the front feet, and add shadows under these feet and the tail.

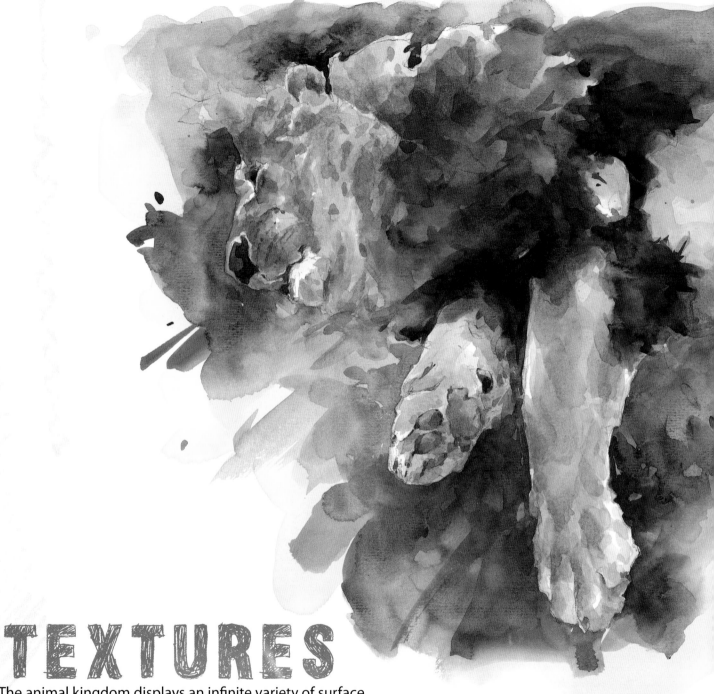

TEXTURES

The animal kingdom displays an infinite variety of surface textures, from fur to scales and, sometimes, both. Portraying a three-dimensional surface in a two-dimensional painting requires an understanding of light and shade. I find that creating an impression of these surfaces is more effective than rendering a photographic likeness.

Sleeping lion

I first applied a wet-in-wet wash for the background and shaggy mane of this sleeping lion. When this was dry, I loosely painted the fur with some wet-on-dry brushstrokes in various shades of brown.

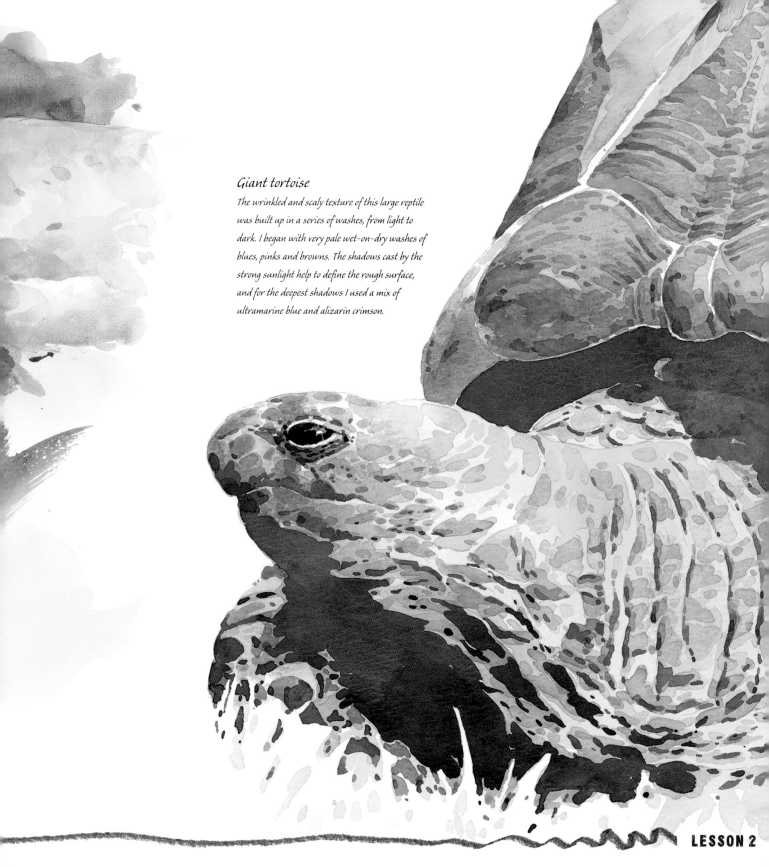

Giant tortoise

The wrinkled and scaly texture of this large reptile was built up in a series of washes, from light to dark. I began with very pale wet-on-dry washes of blues, pinks and browns. The shadows cast by the strong sunlight help to define the rough surface, and for the deepest shadows I used a mix of ultramarine blue and alizarin crimson.

PAINTING FUR

Most mammals, though not all, are covered in fur. This can be long, short or a mixture of both, and comes in a wide variety of colours. A single animal will have a coat consisting of thousands of individual hairs, so how do we go about painting this furry feature?

GIVING THE IMPRESSION

The first thing to stress about fur is that it isn't necessary to paint every single hair; it is more effective to portray an impression of the coat, and you can make fur look light and soft with just a few brushstrokes.

The direction and intensity of light is important: some creatures appear shiny when bathed in strong sunlight, and even a black cat can look very light when viewed in bright conditions.

KEEPING IT LOOSE

The idea for the painting below came about in the spring, when the primroses started to appear in our garden.

🐾 I painted this animal in a little more detail than I normally would, but resisted the urge to overwork by painting every hair and whisker.

🐾 I used dabs of colour to create the texture of the fur, which was built up in several washes, the detail being noticeable on the face and areas of shadow.

Hiding among
the primroses
I sketched this rabbit from life, at Paignton Zoo, where there are plenty to be found grazing in the paddocks of the larger animals. Although the one I sketched was out in the open, I decided to portray it partly hidden.

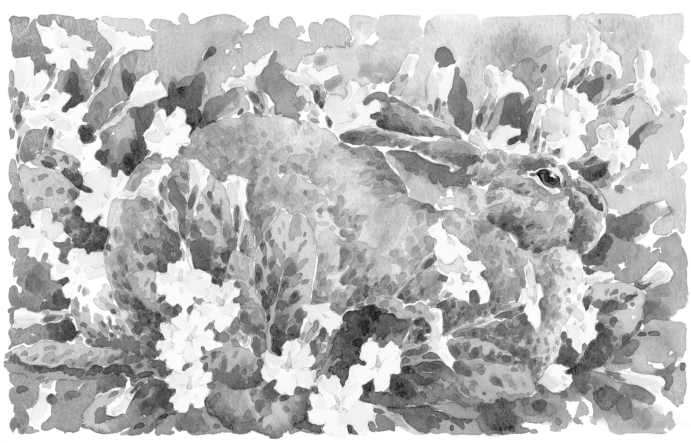

SUGGESTING FUR

These watercolour studies illustrate how you can describe the impression of fur without resorting to photographic detail. Each was painted quite loosely, with just three colours: ultramarine, raw sienna and burnt sienna.

🐾 In the two portraits at the top, the colours were allowed to mix, wet-in-wet, on the page, which accounts for the soft, blurred edges.

🐾 The study below shows the cat on a garden seat in strong sunlight. Again, the initial washes were painted loosely and quite freely, and when they were dry the stripes were painted wet-on-dry.

🐾 The sharper lines of shadow on the bottom of each wooden slat give the impression of bright light.

🐾 In the sketch of the cat on a window ledge (right), the face is partly obscured by a plant and the markings are prominent in the pose.

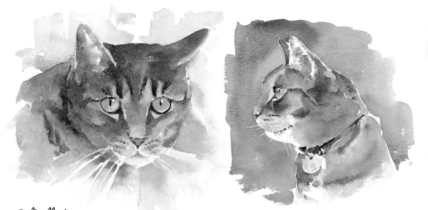

Soft effects

In the portraits above, soft, blurred edges give the impression of patterned fur.

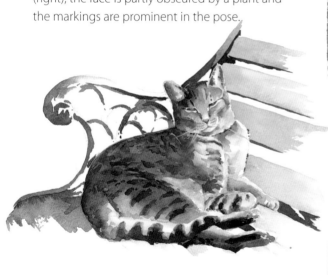

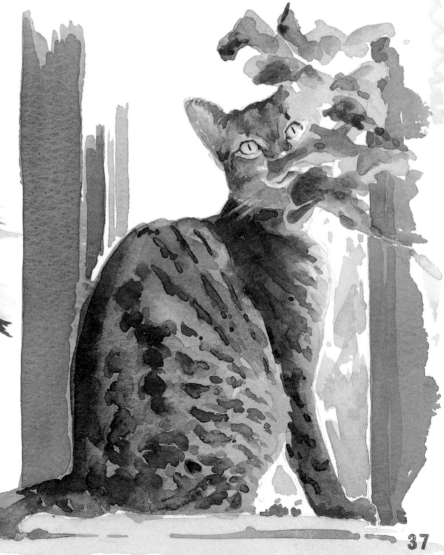

Hard edges

• *In the study above, painting the stripes wet-on-dry gave them sharp edges, which made them stand out from the paler fur. Note how the stripes follow the body contours.*

• *In the sketch at right, both wet-in-wet and wet-on-dry techniques were used for the fur and markings, providing a degree of variety.*

FEATHERS AND HIDES

Not all animals have fur: some have feathers, hides and even scales. Capturing the colours and textures of these different surfaces opens up some new challenges for the artist.

PAINTING FEATHERS

To paint and draw feathers convincingly, it is necessary to study birds. Unlike fur, feathers do not cover the whole of the body; instead, they are arranged along tracts. Feathers are designed for different purposes – for example, those on the breast are short and soft to insulate against the cold, while the wing feathers are more specialist in nature and are designed for flight. There are several types of wing feather, and their arrangement and pattern is crucial to identifying different species. It is a good idea to invest in a pair of binoculars and study some of the different types in your local park or even your garden.

To achieve the appearance of soft feathers a damp brush can be used to blur the edges of any hard lines. Intricate patterns of feathers should be carefully drawn first, then gradually built up with a series of washes.

White feathers

White animals and birds can present problems. Without strong colouring or complex patterns to help us, we must use light and shade to great effect to give the impression of a solid creature. Any textured surfaces will cast shadows in a strong light, and these can be put to good use. Placing white or very pale feathers against a dark background helps them stand out.

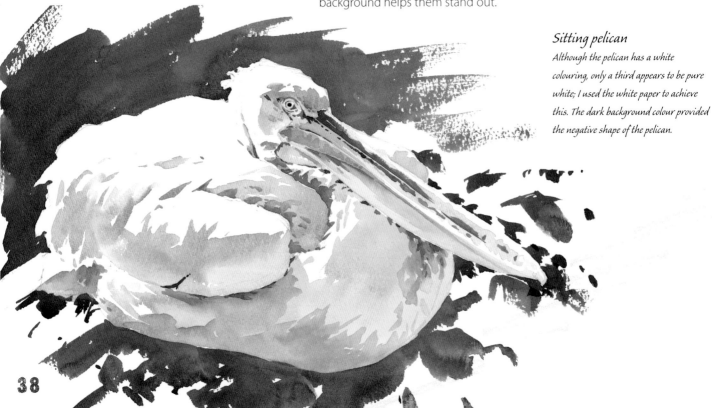

Sitting pelican
Although the pelican has a white colouring, only a third appears to be pure white; I used the white paper to achieve this. The dark background colour provided the negative shape of the pelican.

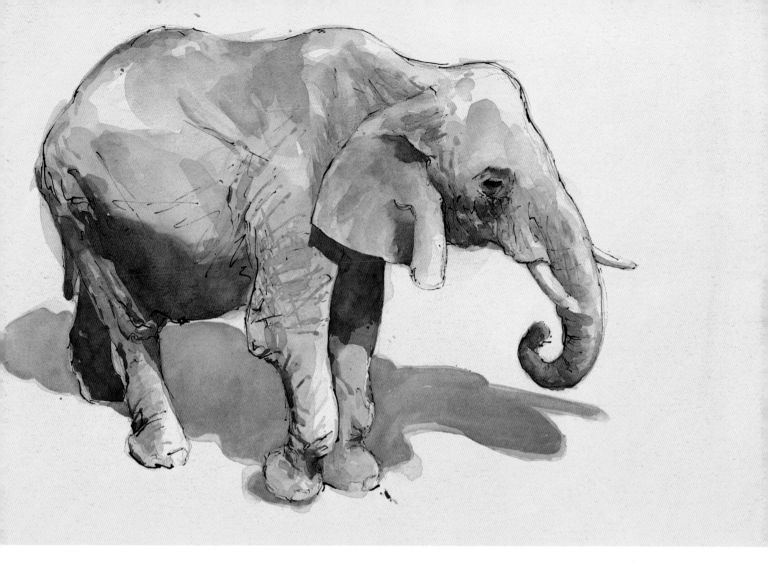

PAINTING HIDES AND SCALES

Animals that possess tough hides or scales make interesting subjects to paint. Once again, light plays an important role in the way we see and portray these surfaces.

Hides often have areas of rough and smooth skin – the rougher parts will show more detail, as any wrinkles or furrows create cast shadows, which are both useful, and a challenge, to the artist. Use harder-edged washes to describe the appearance of wrinkles in strong light.

With scales, look for any interesting patterns – in some species, such as snakes and lizards, these can be complex and colourful; and even the scales of a

bird's leg can show up unexpected patterning and colouration. As with feathers, the intricate patterns of scales should be carefully drawn first, then built up gradually with a series of washes.

USING LIGHT

When it comes to painting all these animals, the most important thing is to study the way that light creates shadows of scales, ridges and wrinkles on the skin. Feathers, too, cast interesting shadows in many different shapes.

African elephant
In this pen and wash study I began with a tinted background wash. The form and shading of the elephant were indicated with various washes of brown. I then picked out just a few lines with a nib – fashioned with a craft knife from a wooden ice-lolly stick – to indicate some of the deeper lines and furrows in the hide.

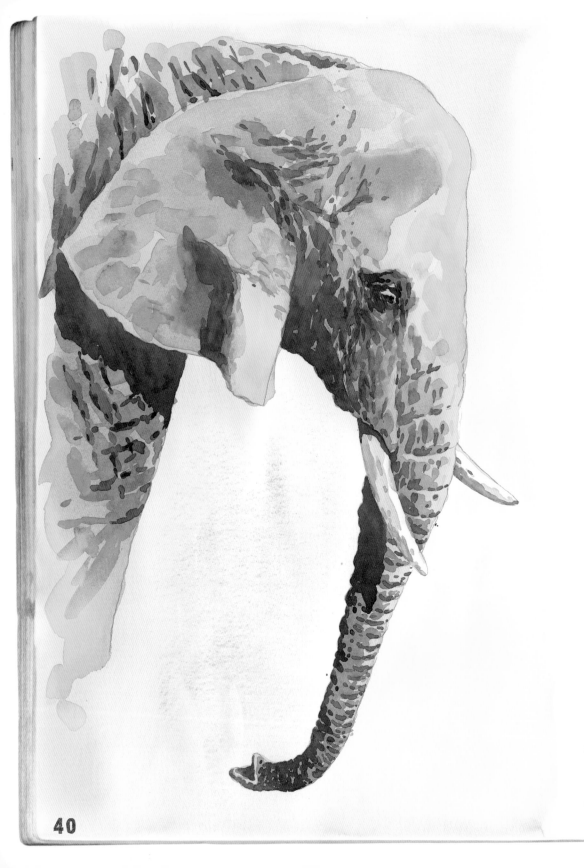

Duchess

Only three colours were used for this project, so it's as much about mixing colours as it is about textures. I drew in just a few folds and creases, and painted the rest as I went along.

ELEPHANT

You don't get much more textured than an elephant's skin, and most zoos and wildlife parks have animals you can sketch and photograph for reference. This is Duchess, an African elephant who lives in Paignton Zoo, very close to where I live. The background was very cluttered in my photo, so I decided to remove it entirely and replace it with a very light, amorphous blend of soft washes.

Note the broken tusk in the photo – I looked at other references and added the missing bit for the project. My sketch for this painting concentrates on the head of the elephant, omitting any background clutter. I drew the position of the features, and the more pronounced wrinkles, straight onto the medium surface watercolour paper with a soft pencil.

burnt sienna

cobalt blue

raw sienna

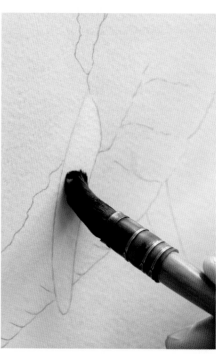

1 Wash over the whole piece of paper with lots of clean water, then drop in some burnt sienna along and down from the top. Mix in some equally diluted cobalt blue; bring these colours around the elephant, and add some raw sienna at the bottom right of the paper.

2 With these first washes, the secret is to work as quickly and confidently as you can. Strengthen the colours a little, this time going over the trunk. Dry the brush and regularly lift out the colours on the tusks, then allow everything to dry completely.

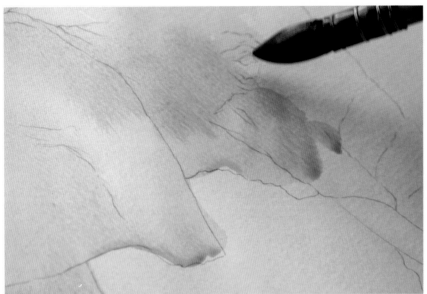

3 Start the washes on the elephant with burnt sienna on the body to the left, then drop in cobalt blue at the top of the head, allowing this to blend, and bring the washes down. Keeping the washes very wet, use deeper versions of the colours for the shadows on the head and body. Work around the tusks and dilute the washes more to fade the colours at the bottom of the leg.

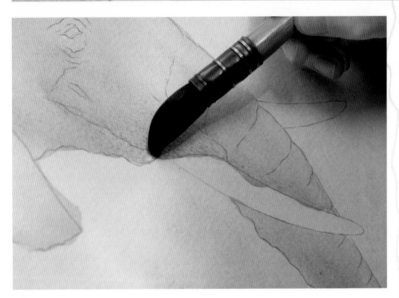

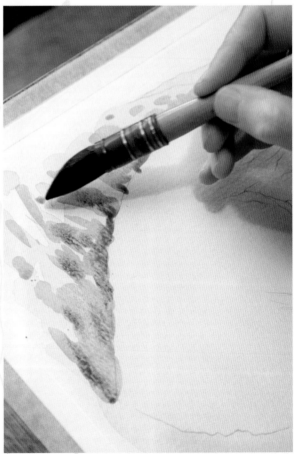

4 Paint down the trunk with burnt sienna, again avoiding the tusks, then drop in cobalt blue on the left, shadowed side. Lift the colour off as required, and allow to dry.

5 For the folds and creases behind the ear, drop in cobalt blue and burnt sienna, and use more blue for the deeper parts and those in shadow. Repeat this below the ear and down the leg, using cross-hatching with the blue.

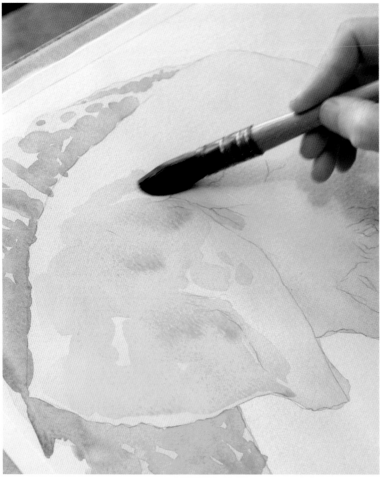

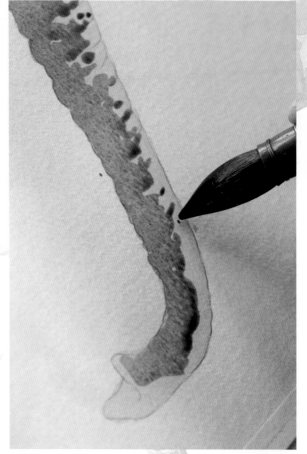

6 Start putting in the shadow areas on the ear itself with burnt sienna, and again drop some cobalt blue into this – these shadows are not from the folds and creases elsewhere, but more from dried mud on the surface of the ear. Where the sun strikes the skull put in a very pale wash of cobalt blue, noting the large depression above the ear for the eye ridge and socket.

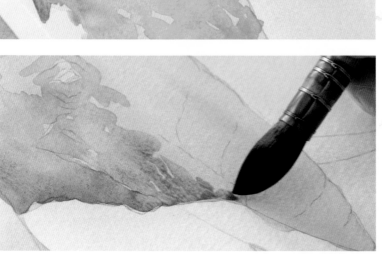

7 Apply some burnt sienna around the area of the eye. Wash this downward, towards the mouth, gradually mixing cobalt blue into the wet paint to create the shadows under the chin.

8 On the trunk the light creates lots of little shadows and highlights: stipple these in with cobalt blue and burnt sienna. Note the shadow cast by the tusk. Towards the bottom pretty well everything is in shadow, apart from the curled-over 'lip' at the end.

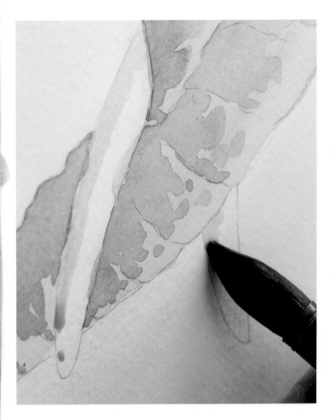

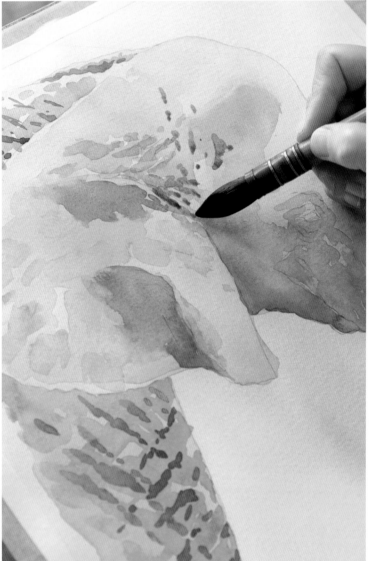

9 Some light raw sienna on the tusks helps them to stand out more and find the colour balance with the rest of the elephant. Use the paint to suggest the rounded (but not round) nature of the tusks.

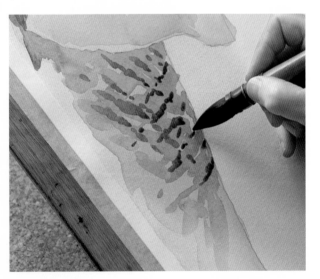

10 Make a grey from burnt sienna and cobalt blue, and use this for more detail in the wrinkles, starting from the top of the trunk and working down. Keep the cross-hatching loose and dotted, to avoid a road-map effect.

11 Add the hollows in the ears, working wet into wet with the grey mix and softening the edges. Then put in the shadows under the chin and around the eyes. With a dark mix paint the eyes, leaving a catchlight of the underwash.

12 Strengthen the shadows below the ear to lift it away from the leg, then add the wrinkles at the front of the ear and deepen the colours in the ear folds. Use the side of the brush to increase the definition on some, but not all, of the cracks in the skin, and warm the top and front of the head with raw sienna.

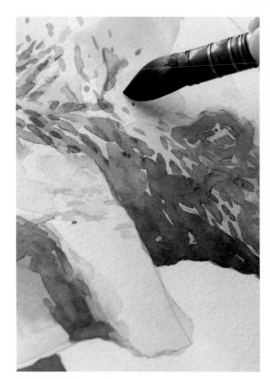

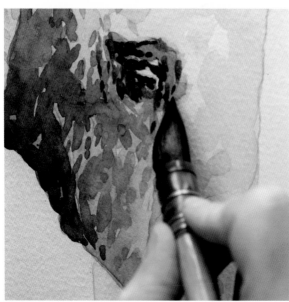

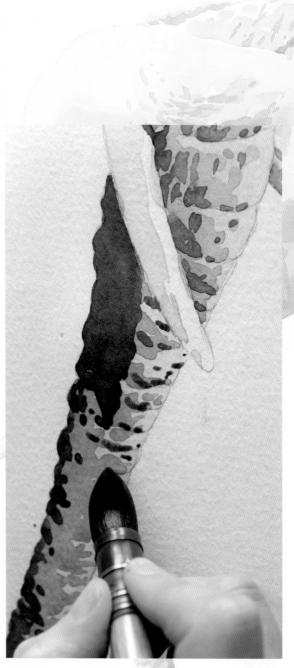

13 Working outwards from the eye, use a strong mix of burnt sienna and cobalt, leaving the eyelid pale for contrast. With the same mix add the small shadow at the top of the tusk, this time with solid edges.

14 Now add the vertical wrinkles on the trunk, as well as reinforcing the ones that go around it. Put in the big dark shadow cast by the near tusk and use broken marks for the deepest shadows down the left side of the trunk.

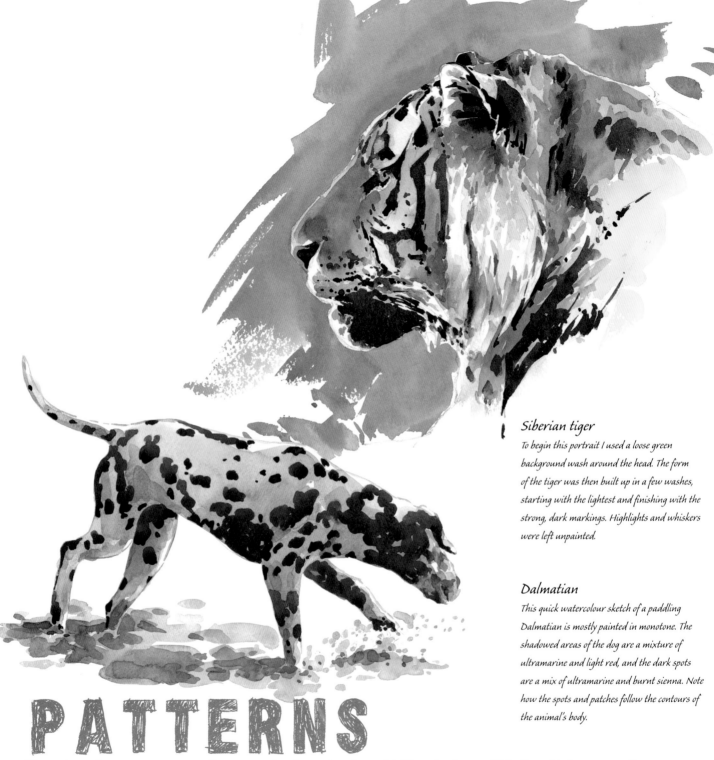

Siberian tiger

To begin this portrait I used a loose green background wash around the head. The form of the tiger was then built up in a few washes, starting with the lightest and finishing with the strong, dark markings. Highlights and whiskers were left unpainted.

Dalmatian

This quick watercolour sketch of a paddling Dalmatian is mostly painted in monotone. The shadowed areas of the dog are a mixture of ultramarine and light red, and the dark spots are a mix of ultramarine and burnt sienna. Note how the spots and patches follow the contours of the animal's body.

PATTERNS

There is an immense range of patterns in the animal world. The designs of Mother Nature usually have a serious purpose, whether to attract a mate or conceal an animal from its enemies. However, the markings of species such as tigers, leopards and zebras make obvious subjects for the artist.

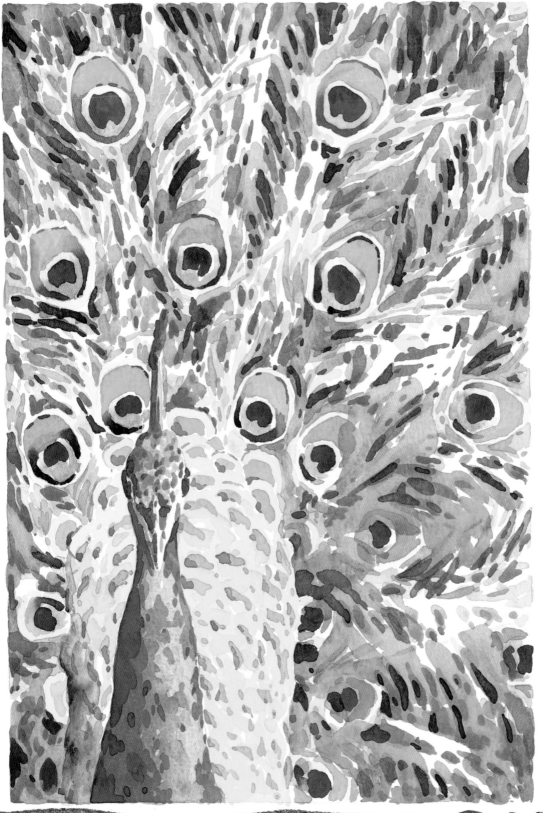

Peacock

I wanted to paint a peacock as an example of patterns. However, rather than portraying the bird in a natural setting, I decided to zoom in close and have the bird filling the entire rectangle of the painting. The bird's dramatic plumage dominates the frame, and the 'eyes' of the tail feathers direct the viewer's attention to the head, deliberately placed off-centre.

I began with an outline drawing, on layout paper, of the head and the 'eyes', which I transferred to watercolour paper. I then used a large mop brush to paint a light wash over the brown areas of the background feathers, working fairly quickly and loosely — in the areas containing most detail there are about three washes.

STRIPES, SPOTS AND CONTOURS

The animal kingdom contains an infinite variety of patterns, ranging from striped zebras and tigers to spotted cheetahs, hyenas and Dalmatians. It pays to study the individual markings of different types of animal, as they are usually arranged in specific patterns. For example, if you were drawing a tiger, it would be a mistake to randomly place the stripes, as the markings are quite specific.

PAINTING SPOTS AND STRIPES

When it comes to painting animals with markings of spots or stripes, I usually begin by laying a wash of the overall colour of the animal; the orange of a tiger or the yellow background colour of a leopard. I then lay further washes to indicate the light and shadows, and the form. The actual markings are painted towards the end, wet-on-dry. Even then, these markings should show variations in light and shade to prevent them from appearing too flat.

CONTOURS

When drawing animals with complex patterns of stripes or spots, bear in mind that the patterns follow the contours of the body, and wrap around the rounded forms of the limbs, body and head.

Study the patterns and markings of animals and familiarize yourself with the way they are arranged. Even the humble tabby cat can teach us valuable lessons. There is usually a strong, black stripe running from the head, along the back and to the tip of the tail. The stripes on the body then radiate from this central line, but observe the way that the stripes rise and fall as they traverse the projecting hip and shoulder joints.

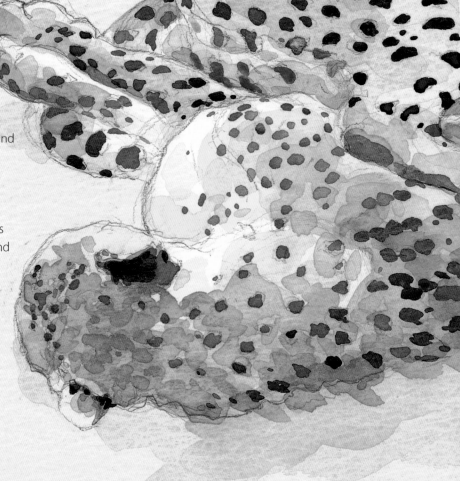

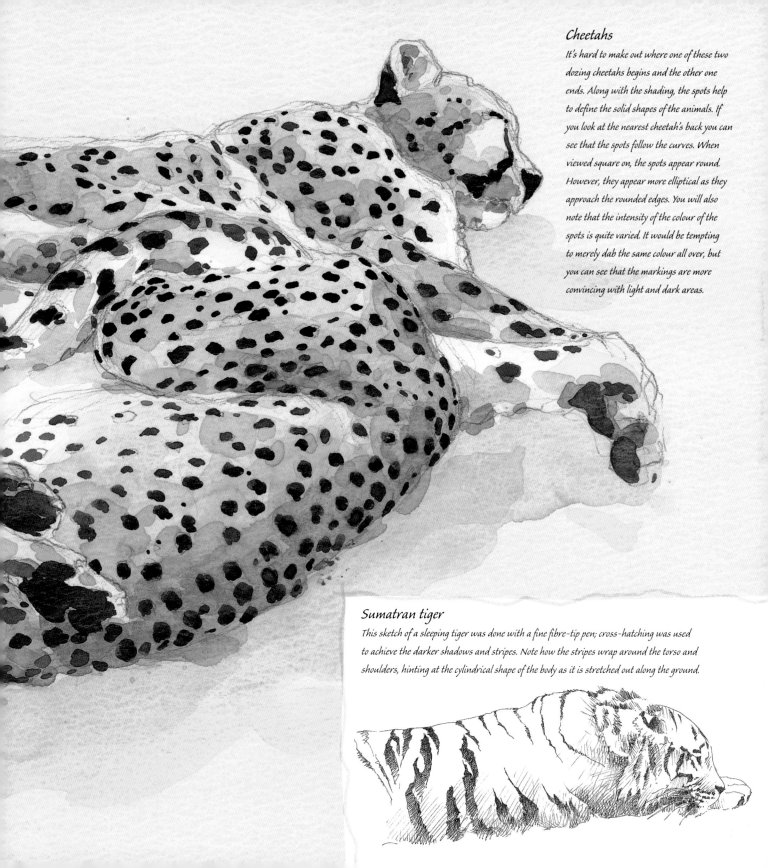

Cheetahs

It's hard to make out where one of these two dozing cheetahs begins and the other one ends. Along with the shading, the spots help to define the solid shapes of the animals. If you look at the nearest cheetah's back you can see that the spots follow the curves. When viewed square on, the spots appear round. However, they appear more elliptical as they approach the rounded edges. You will also note that the intensity of the colour of the spots is quite varied. It would be tempting to merely dab the same colour all over, but you can see that the markings are more convincing with light and dark areas.

Sumatran tiger

This sketch of a sleeping tiger was done with a fine fibre-tip pen; cross-hatching was used to achieve the darker shadows and stripes. Note how the stripes wrap around the torso and shoulders, hinting at the cylindrical shape of the body as it is stretched out along the ground.

CAMOUFLAGE

Many wild animals have developed markings and patterns, which allow them to blend into their natural surroundings. This adaptation can render animals almost invisible.

WHY HAVE CAMOUFLAGE?

There are several reasons why animals display camouflage that ranges from subtle to striking, providing a rich source of detail in your animal paintings. For some predators, such as the tiger, camouflage allows them to hunt unseen. Taken out of their natural environment, their stripes appear obvious. But creeping amongst the tall grasses and stems of its native jungle, it is a different story; the vertical stripes serve to break up its outline, making the tiger difficult to see. With other animals, camouflage protects them from such predators. Most species of ground-nesting bird possess cryptic markings which closely resemble the surroundings in which they nest: for example, the streaky brown feathers of the mallard duck enable it to become invisible against the backdrop of the dead leaves and grasses, where it lays its eggs.

PAINTING CAMOUFLAGE

If you want to illustrate the camouflage colouration of a particular animal, it is important to pay as much attention to the subject's background. The overall aim is to show the animal in its natural environment, as opposed to placing it in a spotlight.

If you are painting a subject that blends against a leafy backdrop, begin by first laying an overall wash across both subject and background (see the Stone Curlew, opposite). The colour of this initial wash will be a unifying colour, present in both. Then build up your subject and background in progressively darker washes, as opposed to finishing the subject and then painting the background. Try to place colours and shapes in your setting to echo the markings of your subject.

Tree frog
Many frogs and toads possess cryptic colouration as an aid to camouflage. The wet-looking skin of this tree frog blends well with the shiny leaves of the plant on which it rests.

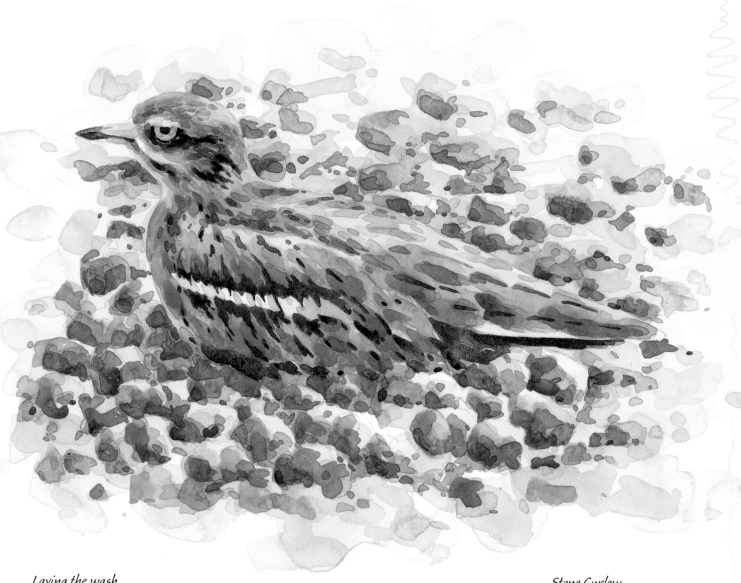

Laying the wash

My original outline sketch (right) shows the main areas of facial markings and plumage detail. The first wash, applied wet-in-wet, goes over both the subject and background. I mixed raw sienna, burnt sienna, cobalt blue and alizarin crimson on the page to set the tone of the final, finished painting above.

Stone Curlew

The browns and blacks of the stone curlew's plumage serve to camouflage this shy bird as it sits on its nest amongst the stones. Most ground-nesting birds rely on their cryptic markings to render them almost invisible. The fluffy down of the newly hatched chicks also resembles the colours of their natural environment, affording them some protection against hunting predators.

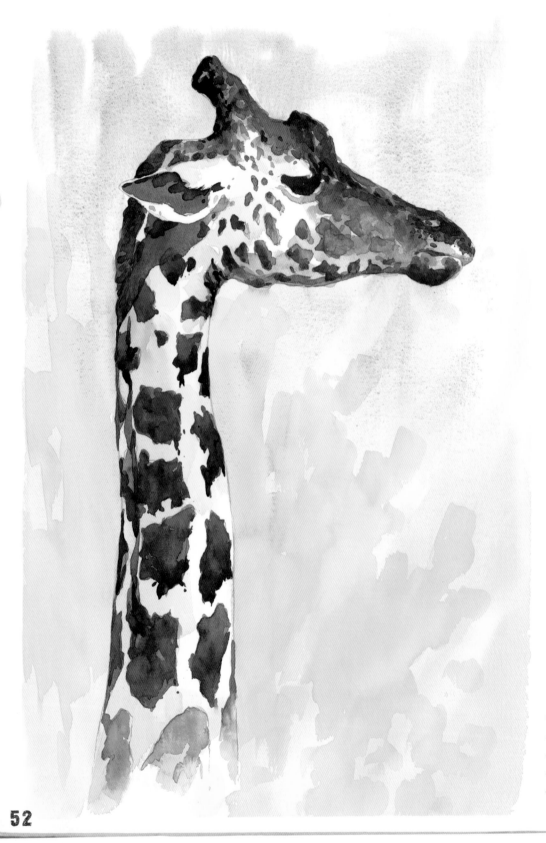

Giraffe portrait
In contrast to the clutter of the
reference photograph, the background
here is muted, allowing the subject to
stand out as the focal point.

GIRAFFE

With such a patterned animal, the most important thing is to capture how the patterns go around the head and neck (and, by implication, the body and legs). The patterns, which have a great variety of sizes and shapes, follow the contours beneath them, rather than lying flat on the skin.

Taken at the zoo, this photo features a lot of crowded, confusing background. In the preliminary sketch I left all the detail out, and traced this onto 300gsm (140lb) Bockingford Rough watercolour paper with a 4B pencil.

cobalt blue

burnt sienna

raw sienna

alizarin crimson

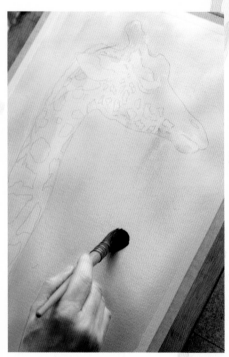

1 Wet the background with water and drop in cobalt blue for the sky area, then separate washes of burnt sienna, raw sienna and alizarin crimson, all very watery. Add more water to soften the washes even more, and don't worry about going over the lines onto the giraffe at this stage.

2 Go over the whole of the washes, dropping in the same colours and leaving the palest parts as white paper. Allow the colours to blend and mix on the paper. Dry the brush and flatten it, then use it to take out some of the wet pigment, creating a few vague shapes. Allow to dry.

3 Starting at the top of the ear, move onto the head with a wash of raw sienna, and bring this down the left of the neck – the part in shadow, as the light is coming from the right. Use a lighter version of this wash on the face in the light.

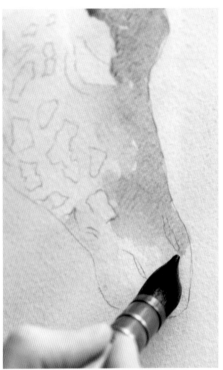

4 While the washes are wet, drop in some burnt sienna onto the horn and above the eye. Make a mix of burnt sienna and cobalt blue and add this grey wet-in-wet to create a variety of colours. Go along the nose, blending the colours on the paper and moving them with a damp, clean brush.

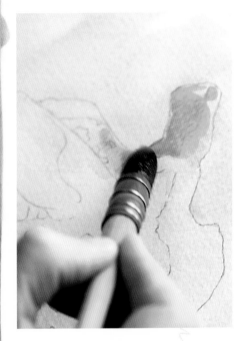

5 Darken the ear with some cobalt blue, then drop in both raw and burnt sienna for the dark shadow under the chin and at the back of the neck. While these are wet, make some vague shapes to suggest the contours and roundness of the neck, again using both siennas.

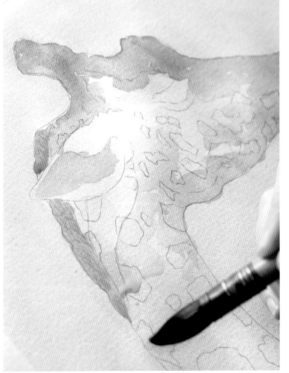

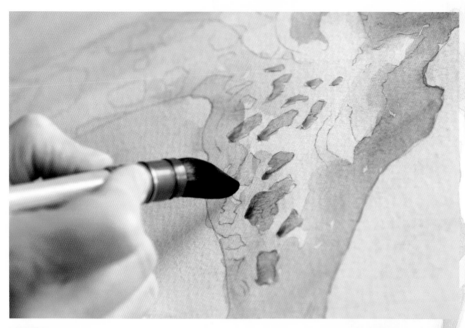

6 When everything has dried, start putting the patterns on the face, first using a mix of burnt sienna and a little cobalt blue for the lightest areas. Then add more blue for the darker patterns towards the underside of the head, and make the whole mix darker under the chin – keep the washes very wet at this point. Run some raw sienna in along the jaw line.

7 Strengthen and sharpen the colours along the top of the head using cobalt blue on its own and a mix of burnt sienna with a little blue. Drop some colour into the eye and work down the mane. Use deep cobalt around the ear (below) to contrast with the white paper.

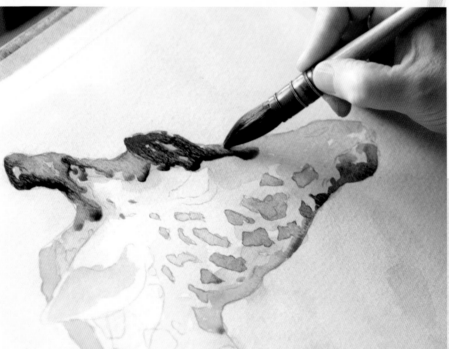

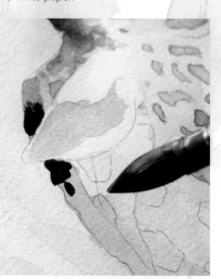

8 Add the patterns down the neck with the mixes and separate colours, mopping up any runs with a damp clean brush. Look for variations in the colours.

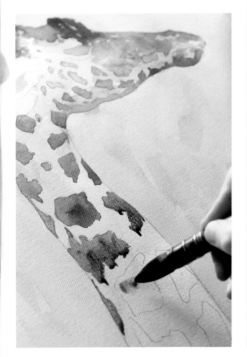

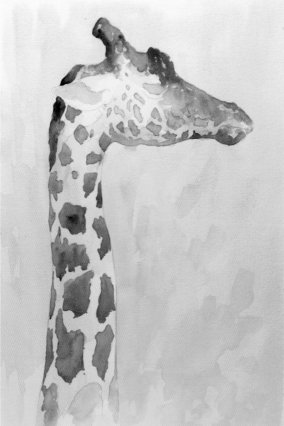

9 To add warmth to the patches lower down the neck, add more burnt sienna to the cobalt blue, and once you have painted it, drop some more blue onto the paper. Fade the very lowest patterns out at the bottom of the page – this looks better than a straight line – and allow all the washes to dry.

10 Use a deep blue cobalt wash and drop in alizarin crimson for the big shadows in and under the ear – again, this isn't a flat colour, so vary the amounts of each on the paper. Use the same colours for the thin crease of shadow down the back of the neck, dropping in wet-in-wet, then reinforce the shadows under the jaw, going over the first washes.

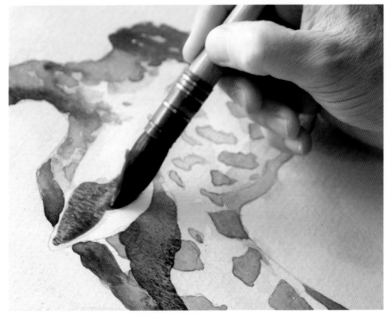

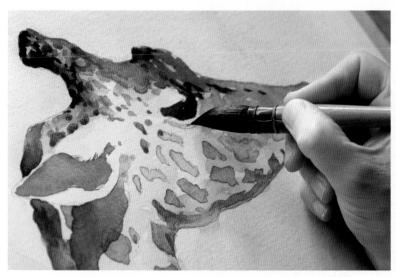

11 Use an almost black mix of burnt sienna and cobalt blue for the eye, and blend the right corner into the other colours on the face. Add darker patterns over the lighter ones across the head, still with very watery washes, and use cobalt blue with a tiny bit of alizarin crimson for the little 'bag' under the eye.

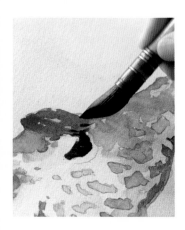

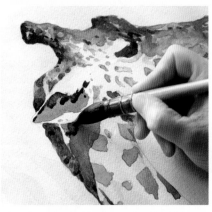

12 Darken the top of the head and the nose with the blue and burnt sienna mix; add more burnt sienna to the mix where the patterns fall away from direct light, to accentuate a colder feel.

13 Start the brown marks in the ear with very wet burnt sienna, then drop in cobalt blue, softening the edges with clean water. Strengthen the big patches down the neck, particularly those just below the ear, which can have quite sharp edges as they are in shadow. Use the tip of the brush for smaller details.

14 Just as with the first washes, fade the darker mixes away on the patterns at the bottom of the page. For the final touches, use less water on the brush and a mix of cobalt blue, burnt sienna and raw sienna around the nostril, and for the speckles around the muzzle, the top of the nose and the line of the mouth – these are very delicate, so don't try to give them too much emphasis.

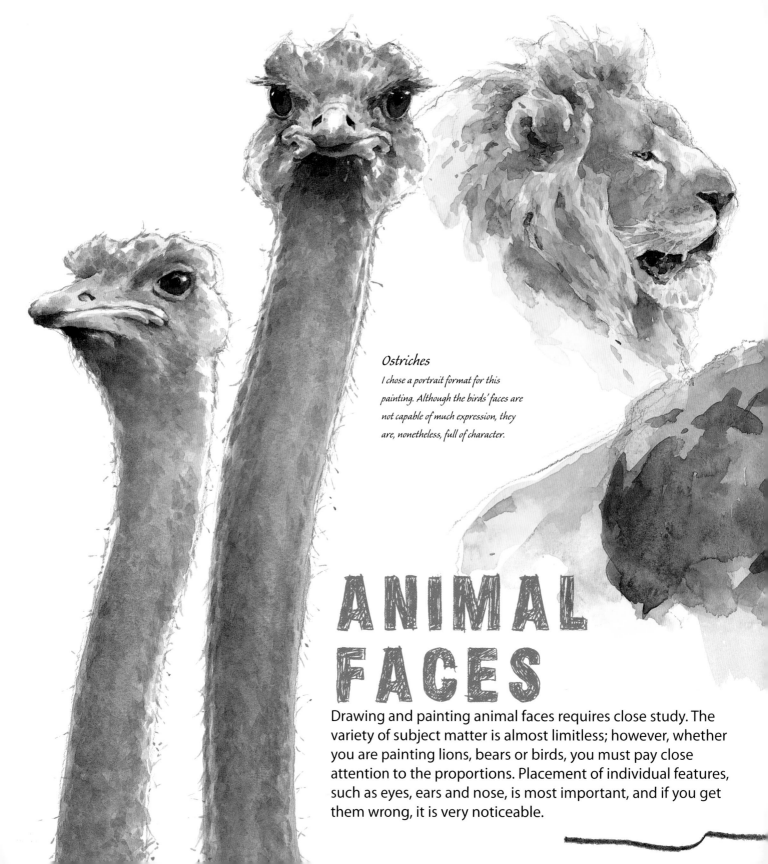

Ostriches

I chose a portrait format for this painting. Although the birds' faces are not capable of much expression, they are, nonetheless, full of character.

ANIMAL FACES

Drawing and painting animal faces requires close study. The variety of subject matter is almost limitless; however, whether you are painting lions, bears or birds, you must pay close attention to the proportions. Placement of individual features, such as eyes, ears and nose, is most important, and if you get them wrong, it is very noticeable.

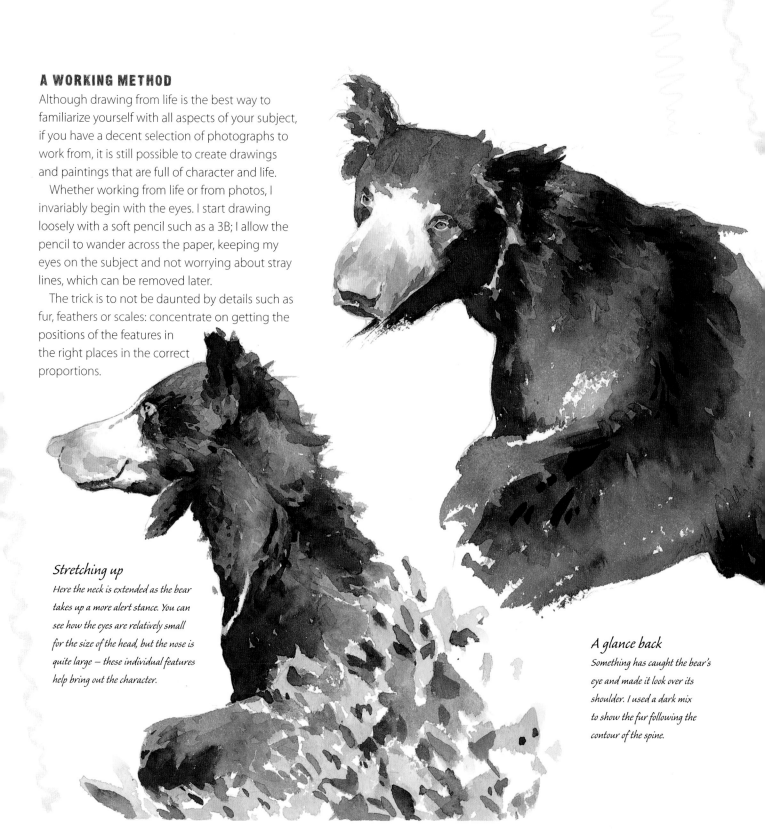

A WORKING METHOD

Although drawing from life is the best way to familiarize yourself with all aspects of your subject, if you have a decent selection of photographs to work from, it is still possible to create drawings and paintings that are full of character and life.

Whether working from life or from photos, I invariably begin with the eyes. I start drawing loosely with a soft pencil such as a 3B; I allow the pencil to wander across the paper, keeping my eyes on the subject and not worrying about stray lines, which can be removed later.

The trick is to not be daunted by details such as fur, feathers or scales: concentrate on getting the positions of the features in the right places in the correct proportions.

Stretching up
Here the neck is extended as the bear takes up a more alert stance. You can see how the eyes are relatively small for the size of the head, but the nose is quite large – these individual features help bring out the character.

A glance back
Something has caught the bear's eye and made it look over its shoulder. I used a dark mix to show the fur following the contour of the spine.

CHARACTER CHANGE

Animals can display a range of facial expressions, which make interesting subjects to draw or paint. Like humans, the character of their expressions may change when experiencing different emotions. They may frown or even appear as if they are laughing.

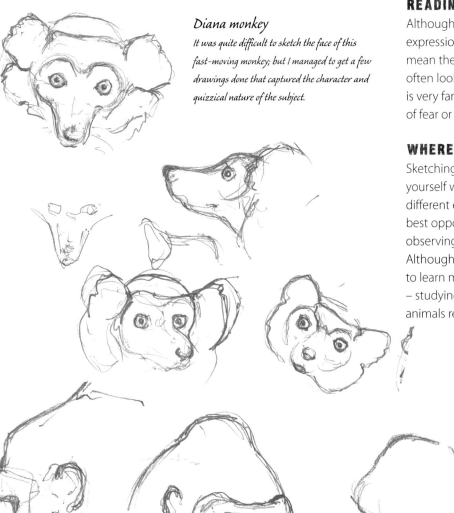

Diana monkey
It was quite difficult to sketch the face of this fast-moving monkey; but I managed to get a few drawings done that captured the character and quizzical nature of the subject.

READING THE SIGNS

Although some mammals often display humanlike expressions, it is a mistake to assume that they mean the same thing. For example, chimpanzees often look as though they are smiling in a way that is very familiar to us; in fact this can often be a sign of fear or aggression.

WHERE TO FIND CHARACTER

Sketching from life is the best way to familiarize yourself with animal features and recognize different expressions. Life drawing provides the best opportunity for studying behaviour and observing how animals react with each other. Although photographs can be useful, it is difficult to learn much about behaviour from a single shot – studying facial expressions and the way that animals react within a group can tell you more.

Gorilla
These powerful apes are mostly placid, which allows the artist to get a few descriptive lines on paper. I tend not to stare at these animals, but take brief glances and then look at the sketch.

Meerkats

On sentry duty, these animals are relatively still; their heads are on the move, but it is usually possible to make some decent drawings of the faces, with their large eyes and pointed features.

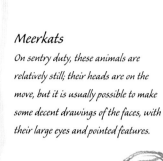

Zoos provide good conditions to study animal expressions and behaviour. Try not to concentrate too much on the detail of the animal. Changes in character may be fleeting, so observe and then describe what you see in as few lines as possible.

TYPES OF CHANGE

Animals show changes in their character with their whole bodies, not just their faces. When a cat is confronted with a rival who has trespassed onto its territory, both animals usually approach each other very slowly, their faces intense with concentration.

They also try to make themselves appear as large as possible by raising their fur on end. They may also present the whole side of their body to the intruder, to make them appear larger.

CHARACTERISING BIRDS

Although birds' faces may not show much expression, they perform displays to express changes in character and emotion. Two male blackbirds show a variety of threatening postures to ward off their rival, from flicking their tails to flying at each other.

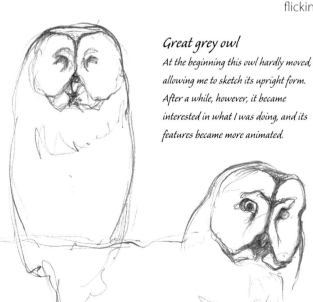

Great grey owl

At the beginning this owl hardly moved, allowing me to sketch its upright form. After a while, however, it became interested in what I was doing, and its features became more animated.

Mandrill

The male mandrill has a somewhat bizarre facial pattern, with pale blue and white cheeks and a red nose. This one gazed at me so intently that I had to look away, even through the thick glass.

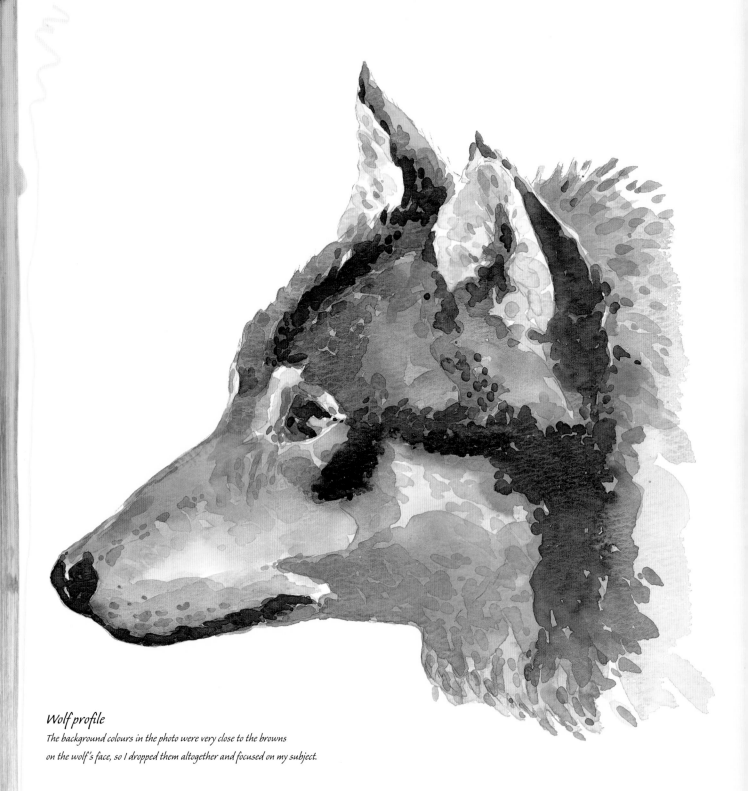

Wolf profile
*The background colours in the photo were very close to the browns
on the wolf's face, so I dropped them altogether and focused on my subject.*

WOLF

With an animal that has a long nose, choosing to paint a profile view of the head is easier than a full-face, head-on view, where you might have to attempt a lot of foreshortening. The markings and the resemblance to a number of dog species are quite prominent here. This wolf, in a zoo, didn't come close to where I was, but this gave me a good overall view.

Not my best photo – but under the circumstances it was as good as I could get, and it tells me enough about the face to go on. I began with an outline sketched directly onto the 140lb watercolour paper, marking carefully the position of the facial markings.

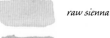 raw sienna

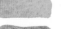 burnt sienna

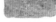 cobalt blue

 raw umber

 ultramarine blue

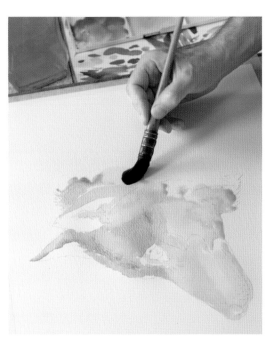

1 For the overall colour scheme and positioning, drop a wet wash of raw sienna onto the far ear, adding cobalt blue in the darker areas. Use the same colours on the brow, darkening them towards the eye. Mix and blend the colours on the paper.

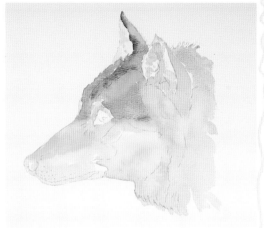

2 Use raw sienna for the near ear and around and down from the front of the eye, then mix this with burnt sienna along the snout and behind the eye. Apply more burnt sienna at the back of the near ear and down the face, mixing this with the raw sienna. Mix raw umber and cobalt blue for the ruff behind the head, and fade this out with a soft edge towards the side of the paper. Allow to dry for a while.

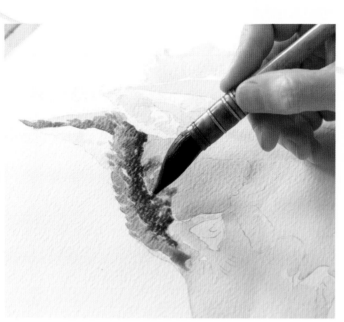

3 Use very diluted cobalt blue, raw umber and raw sienna inside the ears, and raw sienna between the ears. Build up colour along the brow and far ear with cobalt blue, and down the face with burnt sienna, allowing the underwashes to show through.

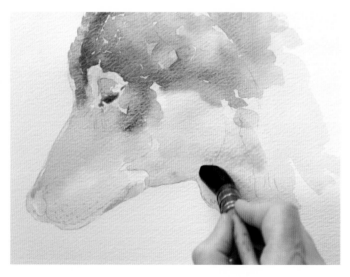

4 Continue with burnt sienna and cobalt blue for further grey markings along the side of the head and behind the ears. Add a cobalt blue and raw umber mix at the back of the head. Reinforce the snout and jaw line with burnt sienna.

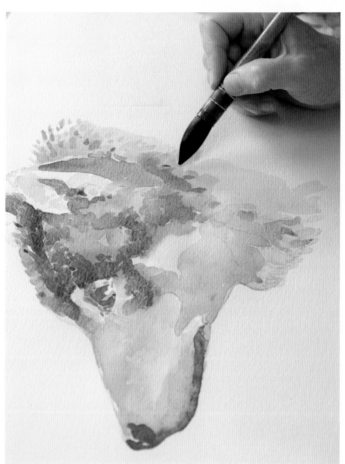

5 Use darker versions of the mixes from Step 4 to define the nose and line of the mouth, using the tip of the brush, and around the eyes. Soften the mouth line with clean water. Build up the shadow and grey areas with the same mixes, and use these washes to add more definition to the markings and around the eye.

6 For the darkest parts – coming down from the tip of the far ear, the central line along the forehead, and the inside of the near ear – use a mix of burnt sienna and ultramarine blue. Block in the dark area below the eye and add more water to this as you go to the back of the head, into the ruff. Use a lighter version of the mix along the muzzle to the neck.

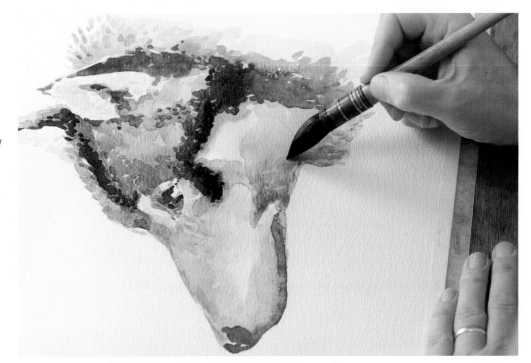

7 For the definition on the cheek apply a mix of cobalt blue and raw umber, softening this at the edges with a clean, damp brush. Use the dark mix from Step 6 to reinforce the nose and the line of the mouth, then add a few whisker holes and markings with a medium mop brush. Finish by painting a few hairs in the ears, and drop just a dot of raw sienna in the eye.

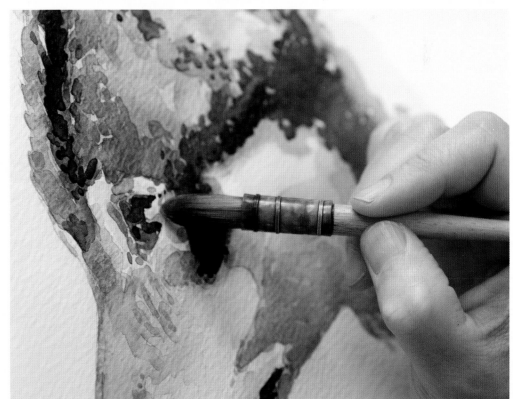

The black-and-white markings of the avocet
make an attractive subject. I first worked out
my composition on thin layout paper before
finally transferring it to the watercolour paper.
I chose a pattern of moving blue water as a
background to contrast with the birds' bold
plumage. In watercolour the lightest colour
available is the whiteness of the paper.

ANIMAL GROUPS

Painting groups of animals provides the artist
with endless possibilities for compositional ideas.
Many species are gregarious and can be depicted
in groups. Larger animals, such as elephants and
cattle make interesting subjects, but so too do
smaller creatures such as rabbits and, from the
bird world, ducks, geese and swans.

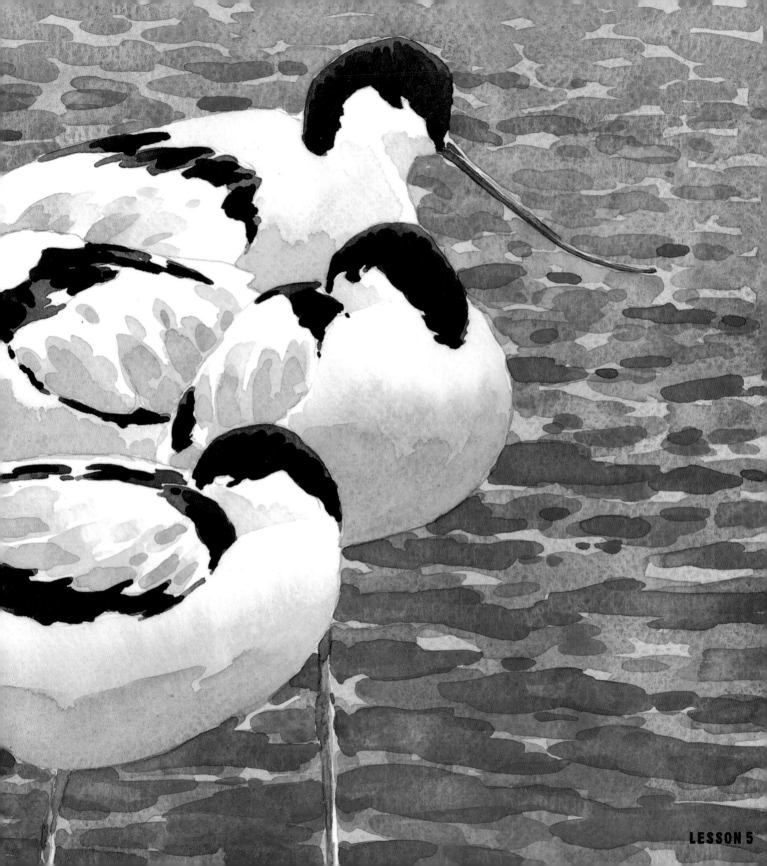

SENSE OF SCALE

Groups of animals can present interesting challenges for the artist. The placing of the subjects in your composition requires careful consideration, and the importance of scale should not be forgotten.

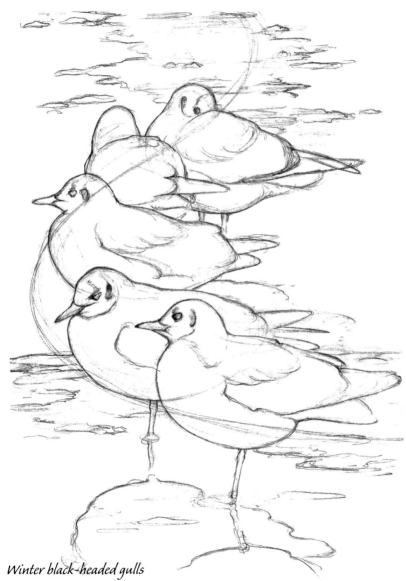

Winter black-headed gulls

This working sketch is typical of the kind I would produce for a painting. I wanted to place the gulls in a way that would lead the eye up the page, which is why I started with the swirling line. I then arranged the gulls along this, ensuring that I kept a sense of scale by subtly reducing the size of the birds as they recede into the background.

REPRESENTING SIZE AND SCALE

When painting an animal group, such as a herd of cows or flock of birds, the animals in the foreground should appear larger, with individual members of the group becoming gradually smaller as they recede towards the horizon. This may seem obvious, but it is something that should be considered and worked out before painting begins. Foreground animals will obviously be portrayed in more detail, with more distant members of the group becoming less distinct as they recede into the background.

When depicting more than one species of animal, it is vital to ensure that the different species are the correct size in relation to each other. Say, for example, you want to paint a marsh or estuary scene featuring a group of wading birds. Waders vary considerably in size, from tiny ringed plovers to large species such as the curlew, and care needs to be taken when drawing individuals in relation to each other. Achieving the correct scale between the different species will result in a more convincing composition.

SCALE AND BACKGROUNDS

Scale should also be considered when depicting the animals' background. A portrait of an animal may show what the animal looks like close up; however, it tells us little about the creature's behaviour and day-to-day life. Most of us see wild animals only fleetingly or through binoculars, but add background and you are instantly transported into their natural environment.

For more on scale, see Lesson 7, Backgrounds and Composition, from page 94.

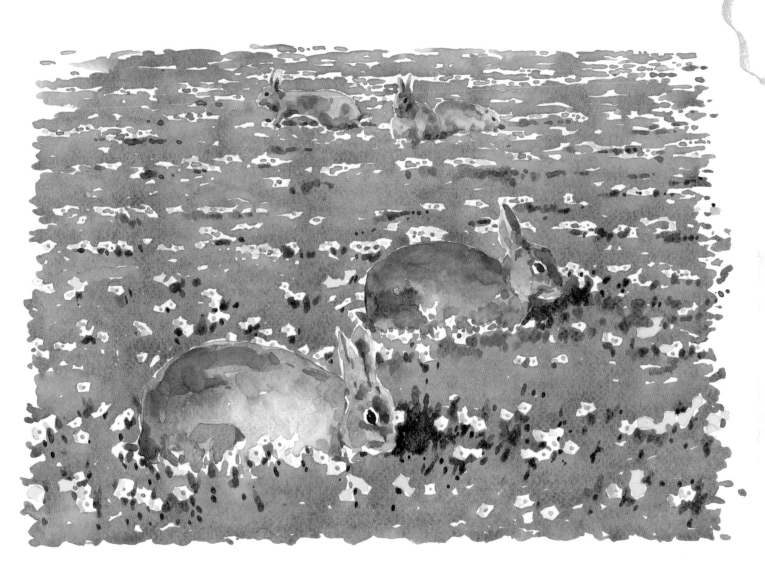

ACHIEVING SCALE IN YOUR WORK

To achieve scale effectively and confidently in your painting, become familiar with a few practical exercises and tips:

❖ To judge differing scales of near and far animals, or objects, try holding your pencil at arm's length. Line up the top of the pencil with the top of the animal nearest to you. Slide your thumb down the pencil until it rests at the base of the animal. Now repeat the process with a more distant animal and compare the difference.

❖ Don't forget to ensure that your painting's background features diminish in scale, as well as your subject.

❖ Foreground animals should be painted larger and in more detail. This gives the impression that they are closer to the viewer.

❖ Distant animals should not be painted in as much detail as foreground animals.

❖ Usually, animals in the distance should be cooler in colour, to give the impression of aerial perspective.

Rabbits in a field

In this small study of a group of grazing rabbits, I painted the two foreground animals larger, with more detail. I used the same technique for the daisies: individual flowers can be seen in the foreground but, as the scene recedes, the flowers are grouped in bunches and the outlines are not so defined.

73

VARIETY

Painting group scenes of animals allows the artist to explore a variety of compositions and ideas. It can be tempting draw an animal in one particular pose and then simply repeat the same shape throughout the rest of the picture, but this is a lazy way of doing things. To give your composition more impact, it is better to show your subjects in a variety of different poses.

FINDING VARIETY

Some animal species are naturally gregarious, presenting opportunities for painting groups. Many bird species gather in great numbers to feed, especially ducks and geese. A visit to an estuary or local pond, particularly in winter, can be worthwhile. Waders and wildfowl walk along the water's edge, probing the mud and turning over stones with their bills in search of food. Gulls tend to congregate in parks at this time. The plumage of wildfowl species can be very colourful, presenting many opportunities for decoration. Larger animals can be portrayed feeding, fighting and running.

CAPTURING INDIVIDUALITY

Study the behaviour of individual animals within a group, as some members may show different habits. Often a gaggle of feeding geese may be engrossed in what they are doing. Look carefully though, and you can often spot one or two with their heads high in the air, keeping a watchful eye on the strange observer. Likewise, meerkats have sentries placed on high ground or perched in the tops of bushes, keeping a lookout.

Make sketches and keep notes of your studies, and you should have an endless supply of reference material for ideas for paintings that feature animal behaviour.

COLLECTING REFERENCES

When I'm sketching birds and animals, whether it is in a zoo, a park or in the wild, I am constantly on the lookout for interesting shapes and poses. If you are taking photographs for reference purposes, again look for variety in the poses. Try to visualize how you might use your sketches and photos in your compositions when you are back home. A collection of sketches depicting a variety of poses and behaviour provides a useful tool. Often a group of animals behaving in a certain way, such as feeding, will suggest ideas for future paintings.

Shelduck
The shelduck in this small group are all shown from different angles. The two nearer birds are resting while the birds in the shallow water are dabbling.

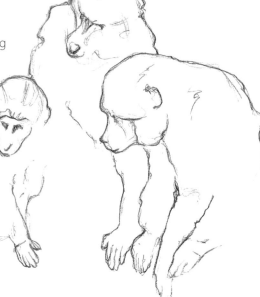

Baboons
These three baboons are obviously intent on something happening below. Although they are looking in the same direction, they are shown in a variety of poses.

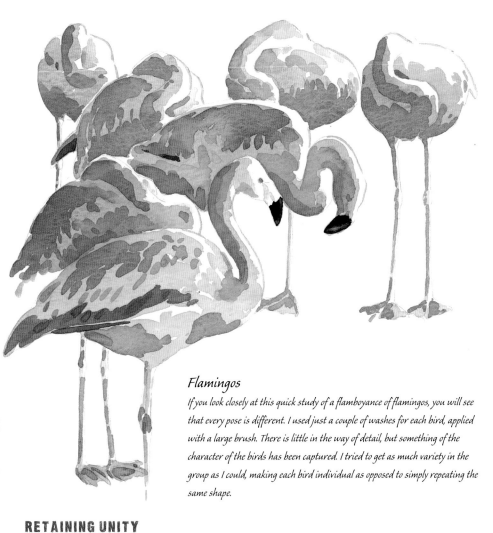

Flamingos

If you look closely at this quick study of a flamboyance of flamingos, you will see that every pose is different. I used just a couple of washes for each bird, applied with a large brush. There is little in the way of detail, but something of the character of the birds has been captured. I tried to get as much variety in the group as I could, making each bird individual as opposed to simply repeating the same shape.

RETAINING UNITY

Try to make your composition flow as a whole. The design of the picture requires serious thought and it is best to put your ideas into rough sketches before committing them to the watercolour paper. When painting groups try to ensure that your subjects appear to belong with each other, as opposed to appearing as disparate objects on the page. In the small watercolour sketch of a group of flamingos, most of the birds are interlocking in some way and, although in a variety of poses, the group works as a whole. Although the birds are of the same colour, I have varied the shade of the more distant birds to make them cooler in tone.

Walking flamingo

I decided to do a little painting of a single flamingo, away from the main group. Like the others, this was painted very simply, with just a couple of loose washes to indicate the shadowed areas. The white of the paper was used for the highlights.

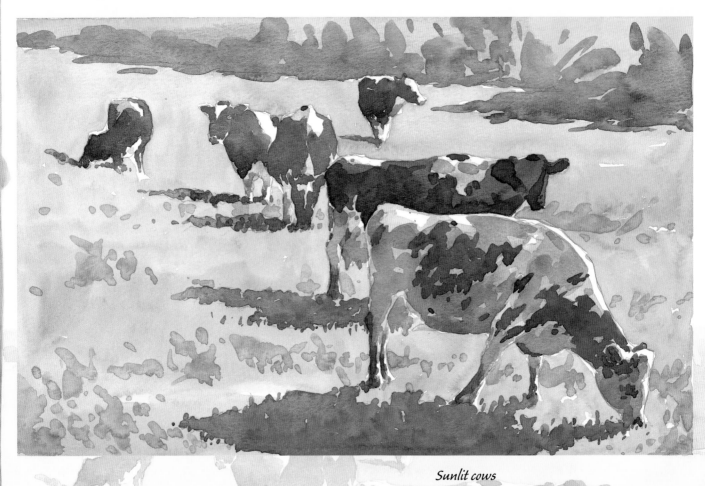

Sunlit cows

The strong spring sunlight coming in from the right emphasizes the shadows, both those on the cows and those cast by them.

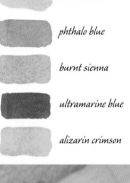

HERD OF COWS

Unless you are extremely lucky, you're not likely to get any group of animals in the best position for a composition for more than a few seconds. This is where reference photos and sketches come in.

When taking more than one reference photo, make sure to take all the shots from the same position so the light and shadows are consistent. My composition also took some working out, as it was based on four photographs. I first sketched it onto layout paper, which is designed for working drawings and withstands a lot of rubbing out. Once I was happy with the design I then traced it onto the sheet of watercolour paper.

raw sienna

phthalo blue

burnt sienna

ultramarine blue

alizarin crimson

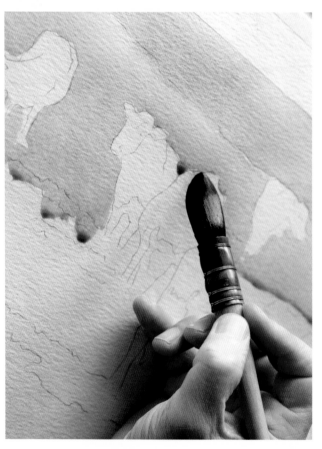

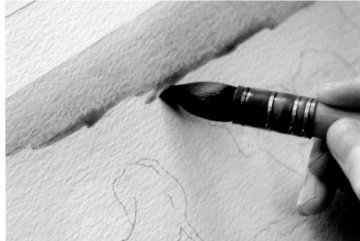

1 Start the line of trees and sky in the distance with a wet wash of burnt sienna, then drop ultramarine blue into this – allow some of the washes to blend on the paper, but leave other areas unblended. Use a dry brush to soak up any runs at the bottom of the washes, and to keep the edges soft.

2 Load the brush with a green mix of raw sienna with a little phthalo blue and paint around the cows, dropping in raw sienna here and there. Try to keep everything very wet and work quickly, including soaking up any runs. Phthalo blue is very strong, so add just a little at a time to the raw sienna.

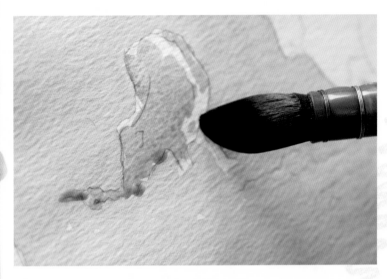

4 On the middle set of 'joined' cows some parts, such as the legs, are completely in shadow; use the same mixes of colours for these. Go onto the foreground pair of cows, leaving just a halo of white paper on the neck and back of the nearest one where the sunlight strikes it.

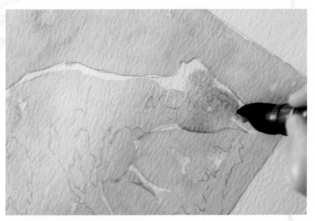

3 For the first shadows on the furthest cow apply light ultramarine blue, then drop alizarin crimson and burnt sienna onto that so that the colours blend on the paper. Suck out the pigment onto the brush and use it for the cast shadows on the grass. Repeat this with the separate cow on the left.

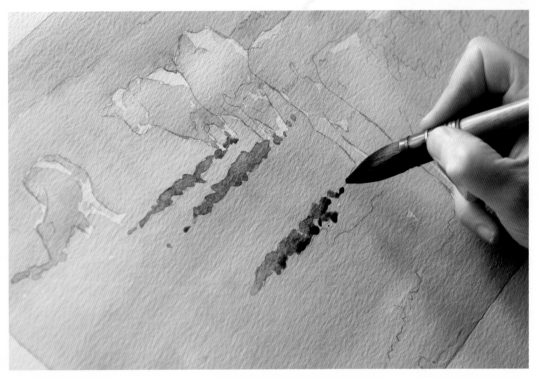

5 The cast shadows anchor the cows to the ground. Working quite delicately, first apply ultramarine blue and then alizarin crimson. Don't just put down blobs of paint, but include indents to suggest blades and clumps of grass.

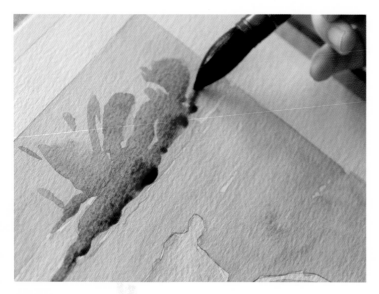

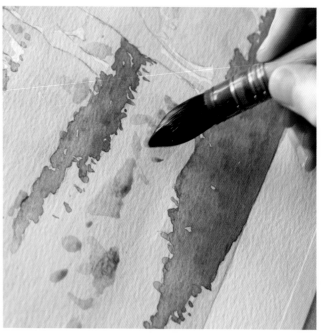

6 Use stronger washes of ultramarine blue, alizarin crimson and burnt sienna to reinforce the woods in the background – aim for shadowy colours with suggestions of trees, rather than actual details. Bring the colours out onto the grass for shadows.

7 Mix the green colour with some raw sienna for the texture and contours on the grass: you need very little further away, but more as you come into the foreground. Allow to dry.

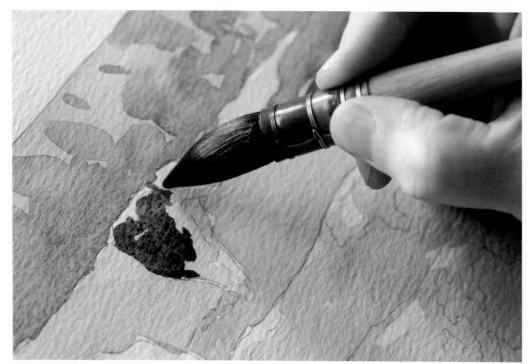

8 Mix burnt sienna and ultramarine blue quite dark for the black patches on the far cows, but use this lighter where the sun catches the markings. Drop in a bit of alizarin crimson while this is wet, and darken the cast shadows as well.

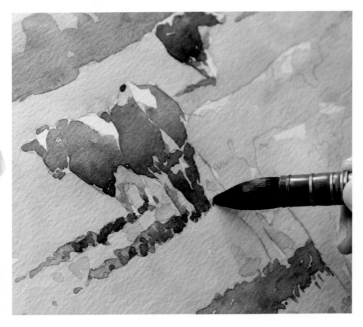

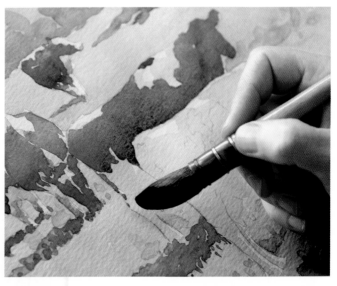

9 Continue with the same colours on the middle set of cows, leaving just a very little white for the sun hitting the white areas. Remember to include the cast shadows, and keep varying the strengths and proportions of the mixes for variety.

10 The mixes for the cow just behind the foreground one need to be stronger still – even where the markings are at their 'blackest' there are differences and variations in the colours, which also help to bring out the contours of the large bodies and heads.

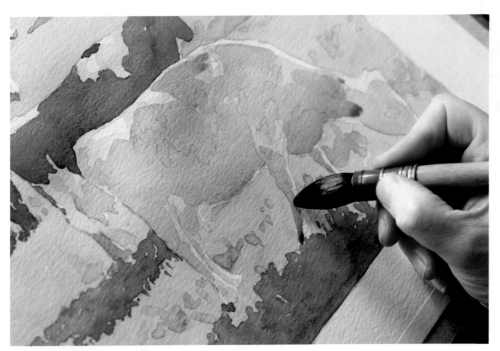

11 On the more mottled foreground cow, first put in a light, wet wash of shadow colours, establishing where the extra shadows are. Allow this wash to dry completely.

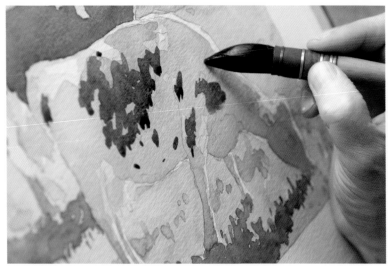

12 For the patterns and patches first apply ultramarine and then drop in alizarin crimson, again following the contours of the animal. Drop in some burnt sienna, this time a drier wash so you have more control. You can't see the eye or any shadow around it, so just paint the patch.

13 Add more detail on the two foreground cows, but keep this simple and not too precise. For the udders apply a mix of alizarin crimson and burnt sienna.

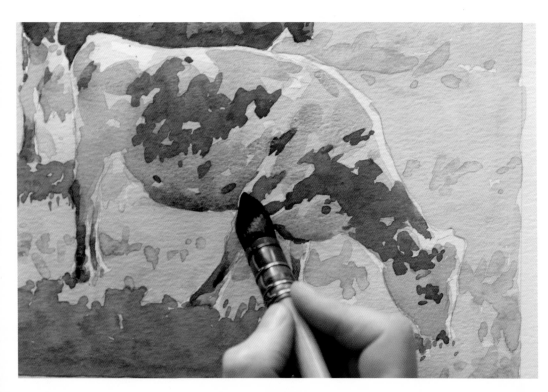

14 Use the darkest shadow mix for the shadows on these cows, making the bony parts stand out white against them. Mix alizarin crimson and ultramarine blue for the shadows at the rear and under the belly, particularly to define the fore leg. Finish with a bit more shadow on the face.

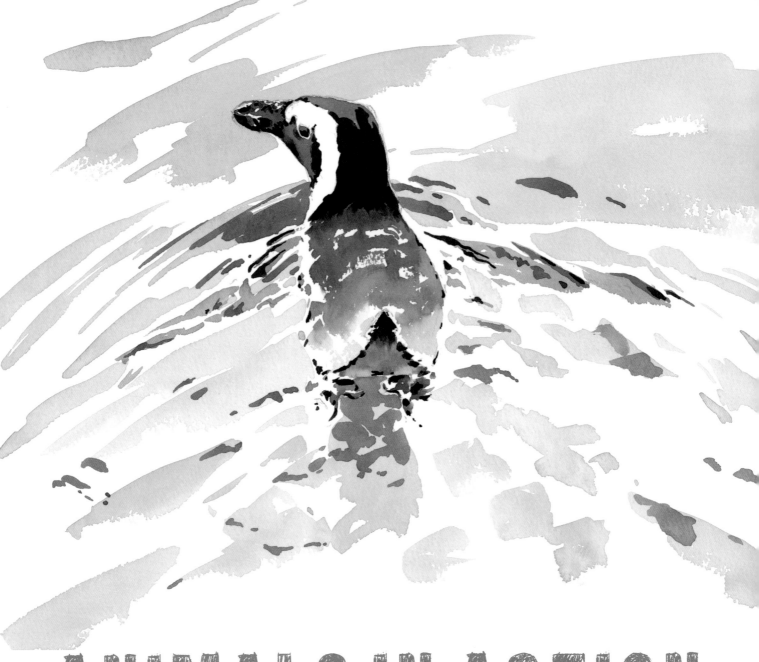

ANIMALS IN ACTION

Once you have gained confidence in drawing and painting animals at rest, it will only be a matter of time before you feel inspired to depict animals and birds in livelier poses. The thought of painting a flock of geese coming in to land or a herd of stampeding wildebeest may seem somewhat daunting, but portraying animals in action convincingly requires careful observation and the willingness to spend some time sketching from life.

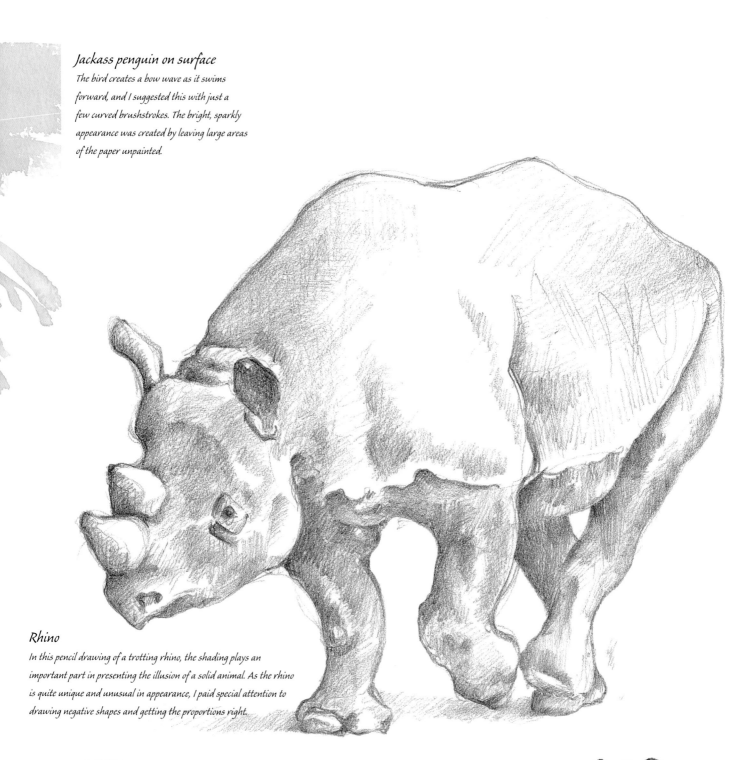

Jackass penguin on surface
The bird creates a bow wave as it swims forward, and I suggested this with just a few curved brushstrokes. The bright, sparkly appearance was created by leaving large areas of the paper unpainted.

Rhino
In this pencil drawing of a trotting rhino, the shading plays an important part in presenting the illusion of a solid animal. As the rhino is quite unique and unusual in appearance, I paid special attention to drawing negative shapes and getting the proportions right.

LEGS AND FEET

Legs and feet tend to cause problems for artists: I've seen paintings where the artist has obviously spent many hours painting the colourful plumage of a beautiful bird, only to place the legs on as an afterthought, like a version of 'pin the tail on the donkey'. And placing your subject behind a conveniently placed rock is not the answer!

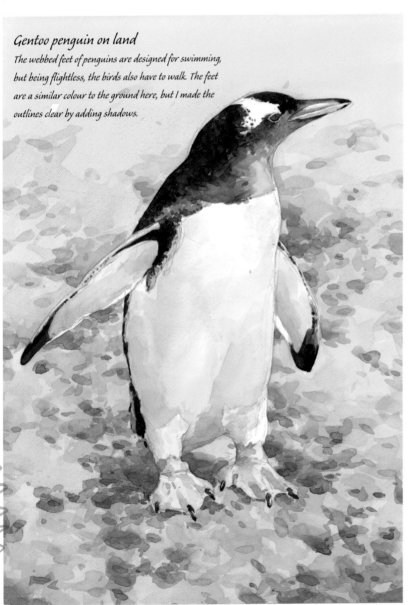

Gentoo penguin on land
The webbed feet of penguins are designed for swimming, but being flightless, the birds also have to walk. The feet are a similar colour to the ground here, but I made the outlines clear by adding shadows.

HOW THE LIMBS WORK

The limbs of different animals can appear very diverse. However, many animals possess a skeleton that is not too dissimilar to our own. They may have much longer or much shorter limbs than humans, but the joints, for the most part, articulate in a similar way to ours. For example, the knee of a bird is very similar to our own in that it can only move backwards and forwards. It's often thought that birds' knees are 'back to front' – however, the joint on a bird, which is sometimes thought of as the knee, is in fact the ankle. The true knee is usually hidden from view among the feathers.

The limbs of larger animals, such as horses and cattle, can be equally problematic. Yes, hooves and claws are probably the least popular parts of the anatomy to draw and paint, but they shouldn't be treated as an alien appendage that you'd rather not have to deal with

PAINTING REALISTIC LEGS

Legs of animals should appear solid and convincing. They should also look as if they are capable of supporting the animal. Follow these general principles:

🐾 Start with a pencil outline, bearing in mind the shape of the animal's skeleton beneath the skin.
🐾 Make sure any sketched stripes, spots or markings look as if they wrap around the cylindrical shape of the leg, rather than lying flat.
🐾 Apply a background wash or two. Ensure that you have a shaded side and a lighter side to make the leg appear solid. Try a watery mix of ultramarine and light red.
🐾 Paint in the legs, using subtle highlights and shadows to emphasize the contours.

USING THE LIMBS

Watch how the animal moves when walking, and see how the feet make contact with the ground. Think of the way an animal's feet, claws or paws are adapted for use in its particular environment. For example, a mouse has nimble claws for holding food and climbing, while a songbird has long, slender toes for gripping branches. How you draw the area where animals stand or perch is important in making them look convincing.

Duck

As with all water birds, ducks and geese appear clumsy on land, walking with a waddling gait. But once on or below the water, they can move quite swiftly.

Elephant

The limbs of the elephant are marked with deep lines and wrinkles. The knees are relatively low down the leg, and the feet are mostly cylindrical, with flat soles.

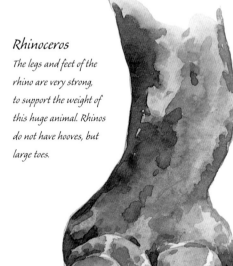

Rhinoceros

The legs and feet of the rhino are very strong, to support the weight of this huge animal. Rhinos do not have hooves, but large toes.

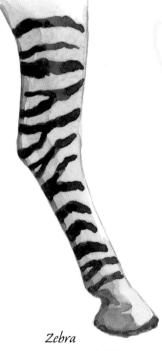

Zebra

An example of a believably strong and solid looking animal leg.

SKETCHING FROM LIFE

As mentioned before, reliance on photographs alone cannot substitute for sketching from the live animal: careful study of a living, breathing creature is by far the best way to get to know your subject. You don't have to go far to find subject matter, either – pets make wonderful models, as do zoo animals.

EQUIPMENT

It is unlikely that you'll get the opportunity to create a finished painting from life, as the elements and your subject matter will seldom allow it, so the less you carry, the better. A sketch is more achievable, and a pencil and pad are really the only items you need. I prefer to use a spiral-bound pad when sketching, as the pages are easy to turn over. The rest of the pad also acts as a portable drawing board. If it's a windy day, it pays to have a few bulldog clips handy to keep the pages from flapping about. A soft pencil, a 3B or 4B, makes a clearly visible line on paper.

Gulls in flight

Just a few lines are all that is required to capture the fluid shapes of these gulls. Armed with a bag of stale bread, I was able to get quite close to these birds as they squabbled over the crusts.

CHOOSING A SUBJECT

Your first subject should be relatively still. Resting animals present ideal sketching opportunities, but even so, you'll be surprised how often they may fidget and shift position in their sleep.

Try to make a quick sketch of the whole animal. I always approach a potential model with the notion that it may not be around for long, so I try to get as much information down as possible with my first few lines. If it turns out that the model doesn't consider me a threat, and decides to stay put, then I will make further sketches.

BUILDING UP CONFIDENCE

You will probably find that your initial marks on the paper will be quite hesitant. Don't worry, you'll soon gain confidence – it often takes a few sketches to loosen up before a drawing starts to flow. If you can, try to move around your subject and view it from several different angles. The idea is to make as many sketches as possible, preferably in different poses. Once you have a few drawings of the whole animal, you can then make separate studies of individual features such as faces and limbs. And remember the chapter on contour drawing? You skipped it? Then go back and catch up. It's a really useful method of working from the live animal.

SKETCHING WILD ANIMALS

Wild animals can be unpredictable and are unlikely to wait patiently while you set up your easel. If you're sketching wild animals in their natural habitat, you may need binoculars or even a telescope to view your subject from a safe distance. Nature reserves can provide good conditions for sketching wild animals, as many have hides, which overlook areas where birds and animals are likely to congregate. Comfort is very important when working out of doors, especially in winter, so hides are very welcome. When the weather turns cold, something to eat and a flask containing a hot drink are just as important as drawing materials.

Keep your eyes on the animal and your pencil in contact with the paper.

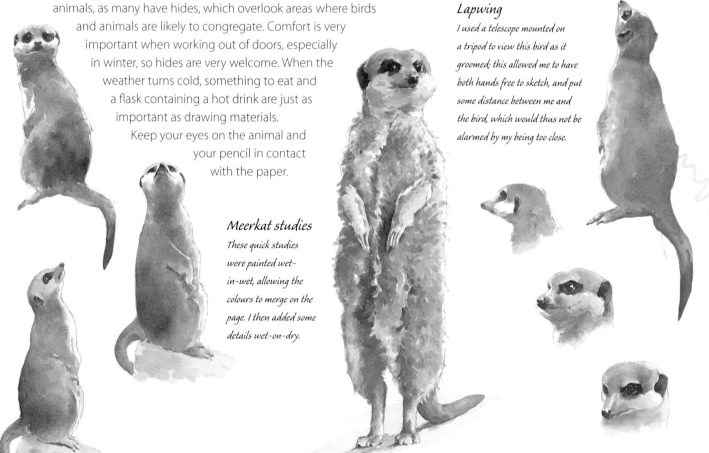

Lapwing
I used a telescope mounted on a tripod to view this bird as it groomed; this allowed me to have both hands free to sketch, and put some distance between me and the bird, which would thus not be alarmed by my being too close.

Meerkat studies
These quick studies were painted wet-in-wet, allowing the colours to merge on the page. I then added some details wet-on-dry.

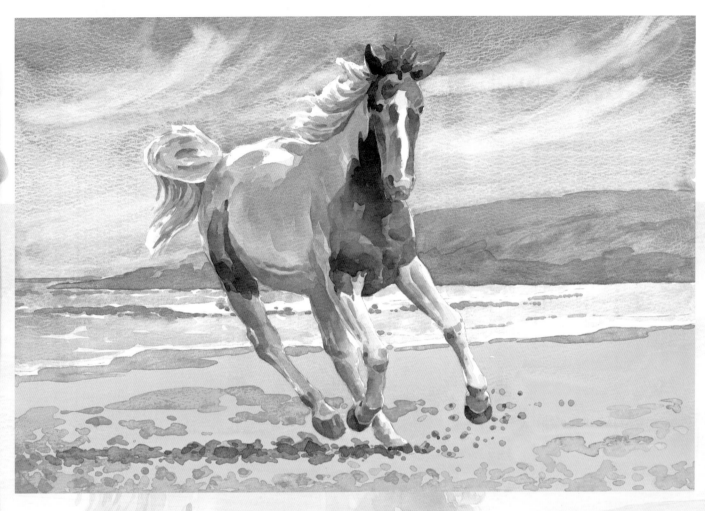

Lolomai Yoki

In the reference photo for this
shoreline, there were buildings and
vehicles in the distance; I removed
these to keep the focus on the horse,
and so the shadows could be accurate.

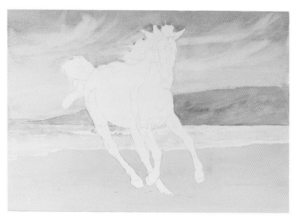

GALLOPING HORSE

A horse at full gallop is an exciting sight, full of power and strength. Viewed at eye level, the impact is immediate – and I zoomed in on the horse from the reference photo to enhance the feeling of 'being there'.

The wooded backdrop in the photograph was not unpleasant, but I decided that it would detract from the horse's movement. I began with a sketch on layout paper, and added the simple beach scene. I then transferred the sketch to the watercolour paper.

 cobalt blue

 raw sienna

 light red

 alizarin crimson

 ultramarine blue

 burnt sienna

1 Use cobalt blue for the sky, working carefully into the edges of the horse's mane. Dip the brush in clean water and dilute the paint as you go towards the horizon. Lift off excess water with a clean, damp brush. Dry the brush and lift off colour in the sky to make 'mare's tail' clouds, then allow everything to dry.

2 Brush clean water onto the headland, then drop in a mix of cobalt blue and raw sienna, remembering the tiny negative shape below the belly. The sea is cobalt blue, with a bit of the green mix dropped in; leave white paper for sparkle on the sea, and between the sea and sand. You can then go straight in with a mix of raw sienna and a little light red – work carefully with both sea and sand colours in the negative spaces between the legs and under the belly.

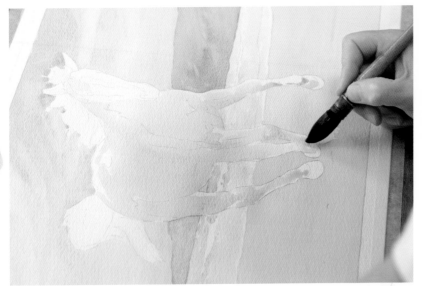

3 Make a watery mix of cobalt blue and light red for the shadows on the horse – this wash covers most of the body, but make sure to leave white areas on the back, mane, face, legs and in the swirl of the tail. Add more red to the mix for the lower shadows, to contrast with the blue of the sea. Soften the shadows with clean water at the base of the mane, and allow to dry.

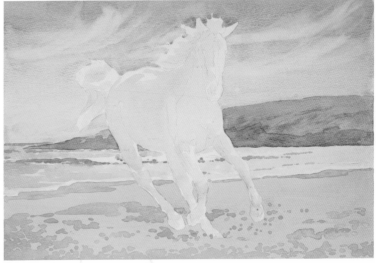

4 Add some more cobalt blue to the sea mix and put some shadows into the sea, dabbing on light lines with the top of the brush to emphasize the 'white horses' at the tops of the waves. Use the same mix for the shadows on the headland and where this meets the sea.

5 Put a weak wash of light red and a little cobalt blue at the edge of the sea and sand, still leaving a tiny strip of white paper. To this mix add raw sienna and a touch more light red for the textures and a few hoof prints on the sand – don't try to put in too many or make them too regular.

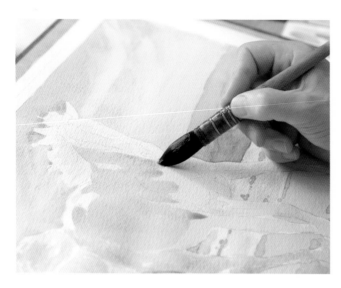

6 Go back onto the shadows on the horse with two mixes of cobalt blue and light red: one with more red for the tail, mane, legs and under the belly, and one with more blue for the bulk of the body. Use the shadows to show the contours and form of this large animal, and leave the white areas as before.

7 Use a darker mix of cobalt blue and light red for the patterns on the rear legs and then the face, leaving the blaze white. Go down the chest and onto the top of the fore leg, then allow to dry.

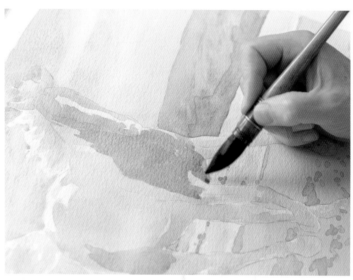

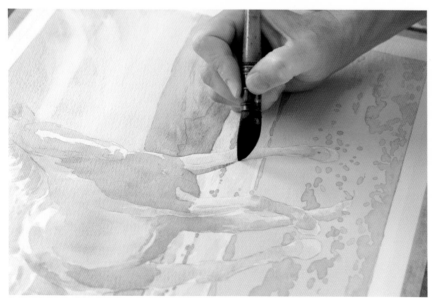

8 Add more light red to this mix and build up the shadows on the back of the mane and going over a little of the white. Reinforce the curl of the tail with these warm shadows. Then go back onto the body and legs, each time using less actual wash and suggesting the darkest areas and the ribs – again, don't try to paint them all.

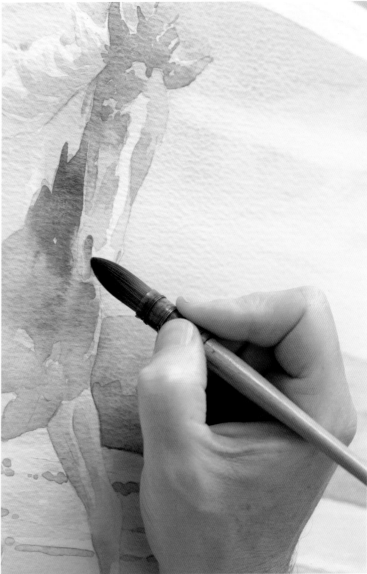

9 Put in the darker shadows on the hind legs, under the belly and around the knees and down the tendons – these lines should emphasize the tension in the legs as the horse gallops into a tight turn. Add the shadows on the hooves, then use a warm version of the mix to start the shadow cast onto the sand, building this up with small dots and marks, rather than a large block of colour.

10 Keep building up the patterns with variations of the shadow mixes. Switch to a medium mop brush for a little detail – the spiky strokes at the top of the mane, the dark shapes around the head, the eyes and nostrils – softening the edges with a damp, clean brush. Use the large brush for the larger patterns in the shadows cast by the head.

11 With the medium brush dot in the nose with a mix of alizarin crimson and raw sienna. Add more crimson for the very fine marks that define the swirl of the tail, and put in a few light strokes along the belly and down the legs.

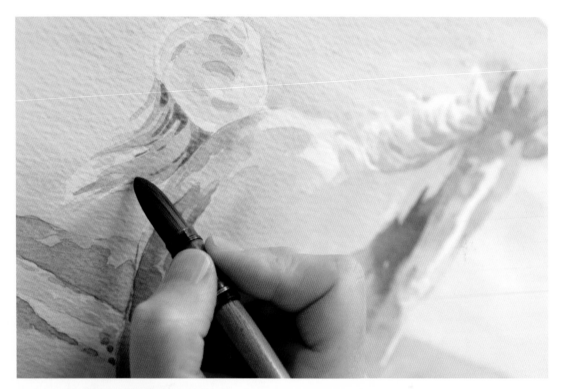

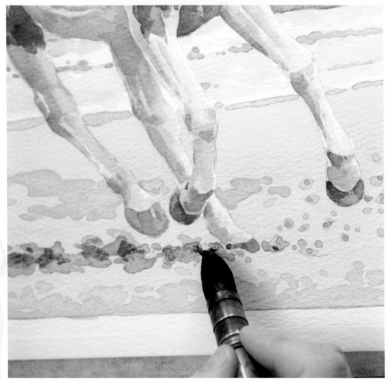

12 Make up a really strong mix of ultramarine and burnt sienna, and use this sparingly for the shadows on the markings. Reinforce the nostrils and the line of the mouth, then the final creases to bring the horse forward from its setting. Finish by darkening the cast shadows on the sand, letting some of the first marks show through.

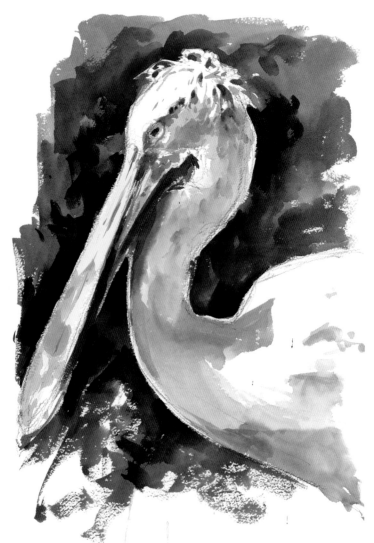

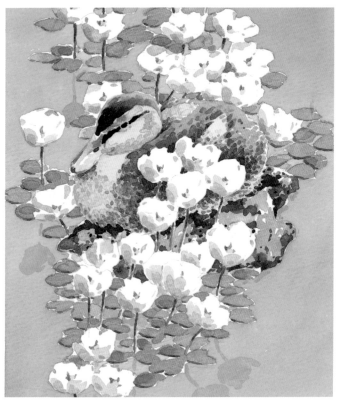

Pelican

I wanted this pelican to stand out from its background, so I first painted the darker backdrop in browns and greens. This created the negative shape of the bird's head. I then painted the shadowed areas of the pelican, leaving the untouched white paper to indicate the sunlit highlights.

Duck and water crowfoot

The delicate, small water crowfoot flowers are essential for determining the size of the duckling; an adult bird would make the flowers look much less substantial.

BACKGROUNDS AND COMPOSITION

The thought that goes into the design and composition of your painting can make the difference between one that is only acceptable and one that demands the viewers' attention. Time spent on ensuring that the background features are interesting and relevant to the painting is as important as the time you spend on painting the main subject. I often get ideas for paintings if I am at the zoo or observing wildlife at a reserve. Ideas need to be worked on, though, and it pays to explore as many design possibilities as possible before finally committing them to your painting.

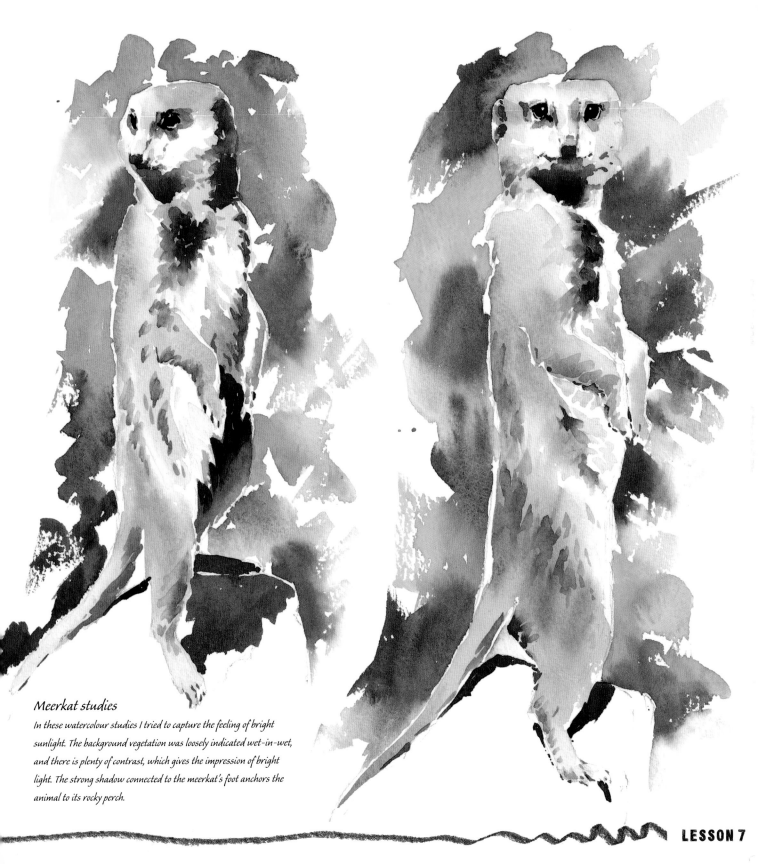

Meerkat studies

In these watercolour studies I tried to capture the feeling of bright
sunlight. The background vegetation was loosely indicated wet-in-wet,
and there is plenty of contrast, which gives the impression of bright
light. The strong shadow connected to the meerkat's foot anchors the
animal to its rocky perch.

COMPOSITION

A pleasing picture requires careful thought and consideration in its design and composition: a painting of a bird on a twig placed in the middle of your paper will not be particularly stimulating or visually inspiring, no matter how skilfully it may be drawn or painted. A little thought on the arrangement of elements within the picture area, before brush makes contact with paper, is well worth the effort.

PRELIMINARY WORK AND PLANNING

If you have a subject in mind for a painting, it pays to make a number of small preliminary sketches. These should not be carried out in any great detail, as they are just meant to promote ideas for a good design. When making such small drawings, try to think what message you are trying to convey to the viewer. What was it that attracted you to the subject in the first place? Is your subject feeding, hunting, resting? You may feel you want to isolate your subject against a muted background, to draw attention to it; alternatively, you may want say something about the way it blends into the background of its natural habitat.

If I am working on a painting that may contain a number of elements, I work on a number of sketches first. Once I've finished one sketch I usually find that other ideas spring from that. When I'm happy with a design idea, I sketch it out in more detail to the size and dimensions I want. I use layout paper for this job, as it is very thin and can take a lot of working out and erasing; watercolour paper has a soft surface, which does not stand up to a lot of abrasion. I then transfer the design to watercolour paper, ready for painting.

PENGUINS

I wanted to paint a group of penguins, so I explored several ideas with this group of four small compositional sketches.

1 *I first sketched a small group with another individual wandering over to join them. Two of the group are looking away from the others, to the right. Your eye naturally follows their gaze to see what they are looking at. I then placed a single bird approaching from the top right hand corner. I made him a little smaller to indicate that he is slightly further away. The smaller bird balances the overall structure and tells a story. However, if you place a hand over the bird you will see that the picture loses something and the composition is less interesting.*

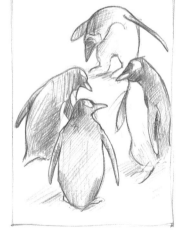

2 *In the second sketch I decided to bring the individual penguin into the group and rearranged the birds to form a circular design. All members of the group are now facing inwards, and the outstretched wings of the top bird help to reinforce the circular composition.*

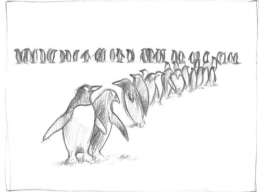

3 *The third example is completely different from the previous two. In this one I wanted to depict a greater number of birds. I created a line of birds along the top third of the frame. I then placed a couple of birds in the foreground and, behind these, a meandering line of birds leading the eye to the main group in the distance.*

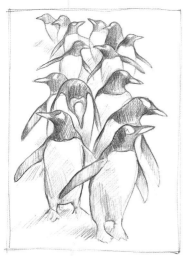

4 The final sketch shows a smaller group approaching the viewer. A central line divides the portrait format, but the composition is balanced by arranging the birds in pairs, with several individuals looking out of the frame.

Gentoo penguins

I decided to use my second compositional sketch as a basis for a painting. I worked up the idea on thin layout paper on a larger scale, refining the design and ensuring that details and markings were correct. The painting was then done quite quickly, using a wet-in-wet mix of ultramarine and burnt sienna for the shiny black backs of the birds. Some shadow was applied to the snow areas, but the lightest parts of the painting were left as pure white paper.

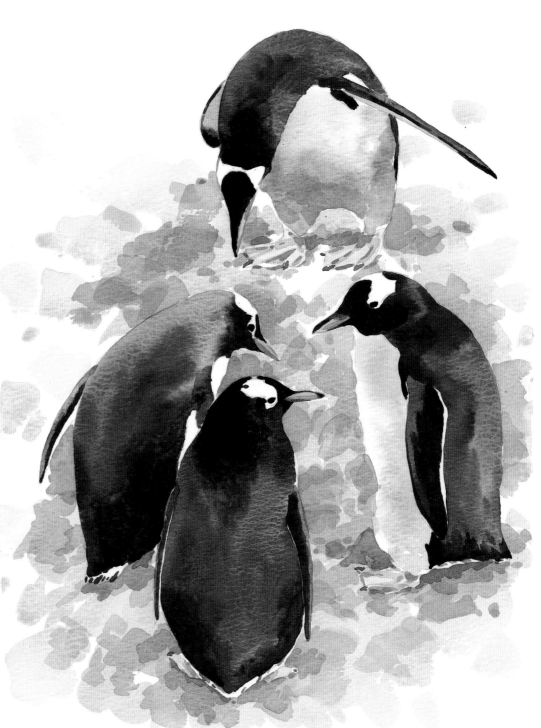

NEGATIVE PAINTING

When we look at an object and then attempt to draw it, our minds can often fool us into seeing what we think is there. If we are used to looking at something, it is more than likely that we have a preconceived idea of what it should look like. This then influences what we draw, which may be quite different from what is actually there in front of us.

FINDING NEGATIVE SHAPES

In order to make a true likeness of your subject, you must try to detach yourself from your mental picture and see it as something quite new. One method of doing this is to look for negative shapes.

Put simply, a negative shape is the area or space that surrounds the object you are looking at. There may be times when a particular part of an animal may cause problems when you are trying to draw it. This is especially true when, say, a limb is being viewed from an odd angle. In such a case it may be easier to try to forget that you are drawing a leg or a paw, and instead, concentrate on sketching the space that is occupied around it. Try to think of the shapes like pieces of an interlocking jigsaw.

Rhinoceros
The outline of the sunlit upper half of the animal is created by the background colour, which I painted first; this is the negative shape. Underneath I painted the rhino itself.

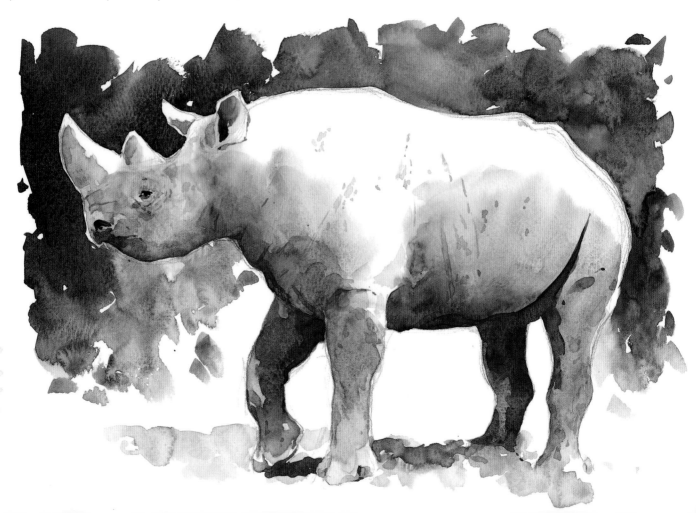

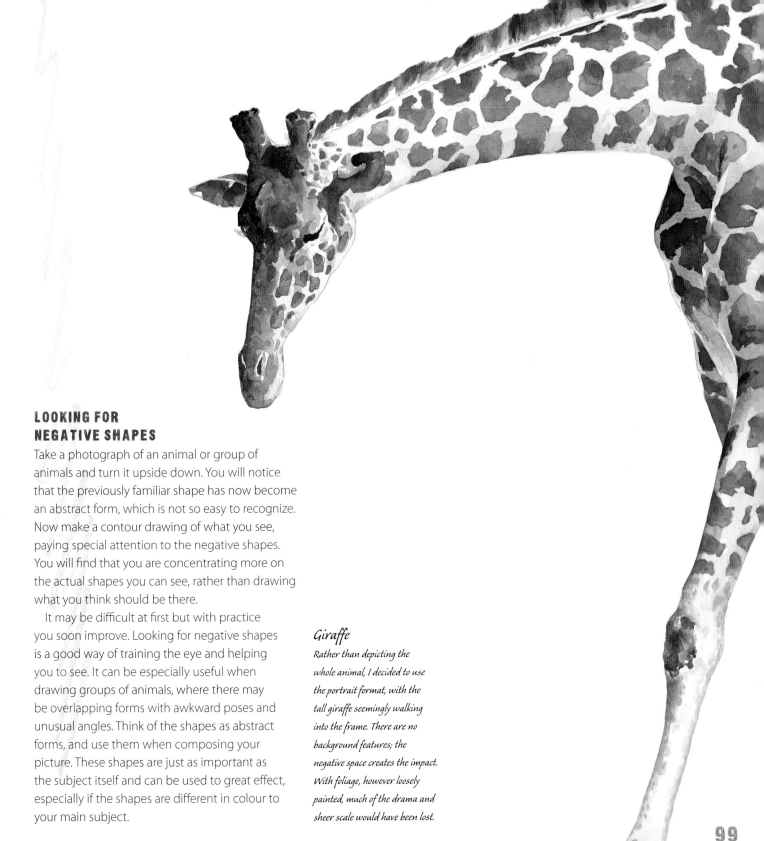

LOOKING FOR NEGATIVE SHAPES

Take a photograph of an animal or group of animals and turn it upside down. You will notice that the previously familiar shape has now become an abstract form, which is not so easy to recognize. Now make a contour drawing of what you see, paying special attention to the negative shapes. You will find that you are concentrating more on the actual shapes you can see, rather than drawing what you think should be there.

It may be difficult at first but with practice you soon improve. Looking for negative shapes is a good way of training the eye and helping you to see. It can be especially useful when drawing groups of animals, where there may be overlapping forms with awkward poses and unusual angles. Think of the shapes as abstract forms, and use them when composing your picture. These shapes are just as important as the subject itself and can be used to great effect, especially if the shapes are different in colour to your main subject.

Giraffe

Rather than depicting the whole animal, I decided to use the portrait format, with the tall giraffe seemingly walking into the frame. There are no background features; the negative space creates the impact. With foliage, however loosely painted, much of the drama and sheer scale would have been lost.

99

BRANCHES AND GRASSES

Background features are an important part of any animal painting, and should be considered at the planning stages of your composition, rather than being dropped in as an afterthought. They can form an integral part of your design and, if placed with care, can be used to lead the eye into the painting.

USING REAL BACKGROUNDS

Most animal settings feature natural forms such as branches, trees, rocks and grasses. If you are sketching animals from life, it makes good sense to sketch these features while you are at the location. These can be done after you've sketched your main subject, or when you are waiting for it to return. If your sketches are done on the spot, your background details will be authentic. The backgrounds should harmonize with the centre of interest – the animal should appear as part of its environment, and shouldn't jar against it.

Cat in the grass
By allowing the first washes for the grass to blend on the paper, I created areas of light and shade.

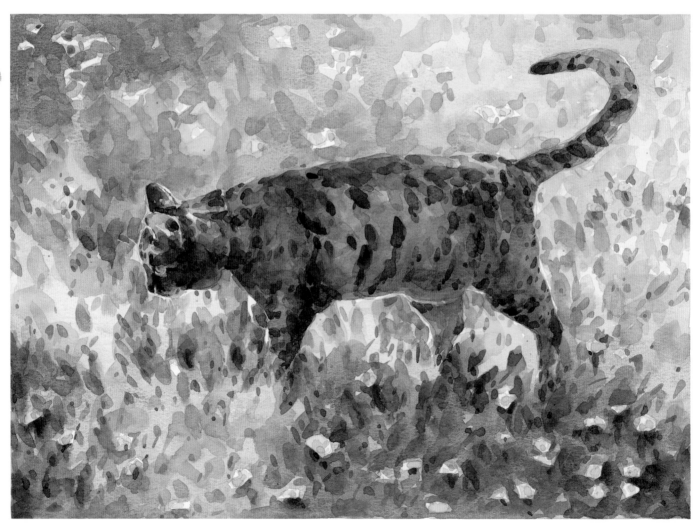

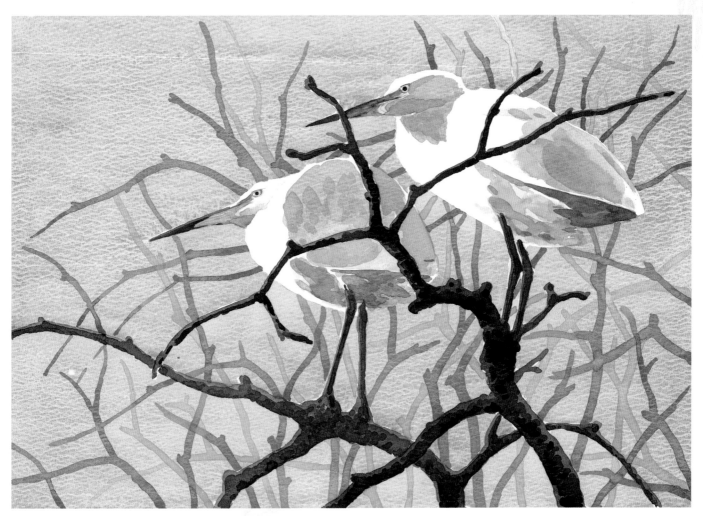

Ensure that light and shadows falling on your animal subject match up with the light on the background. This is particularly important when working from photographs, especially when using more than one. However, branches and twigs can be relied upon not to fly or run away, and should be sketched from life whenever possible.

Don't get caught in the trap of drawing every twig and blade of grass. Near-photographic detail does not make a painting look any more convincing. Instead, try to concentrate on the masses. Use a larger brush to wash in areas of light and shade, and just pick out the more prominent features. Keep detail in the foreground and allow background areas to be more muted.

Egrets on a branch

To suggest a tangle of branches I started with a drawing, indicating the birds and the main branches. I then painted a background wash over the sky area, of cobalt blue mixed with a little alizarin crimson. After this had dried I built up the background branches, drawing them with the brush. The larger foreground branches were painted with several washes to make them stand out from the background. The lighter parts of the two birds were left unpainted.

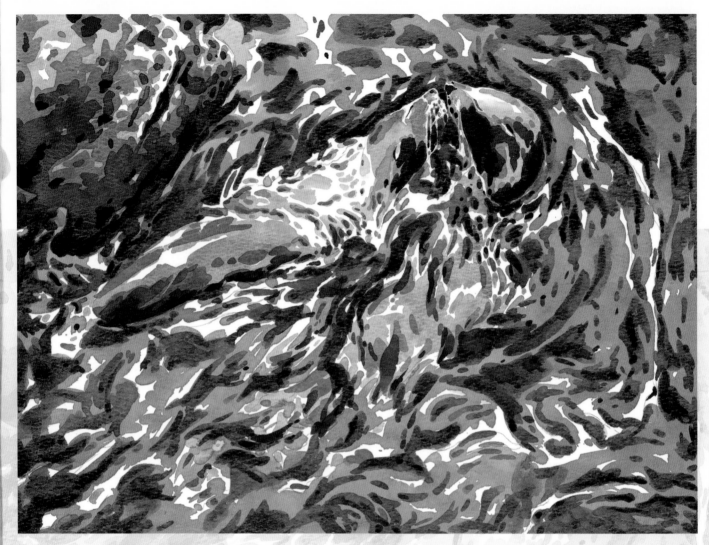

Seals and rocks

Seals are not just a uniform grey! There is as much variation in their coats, especially when they are wet, as there is in the eddying water and on the textured rock.

SEALS

We've looked at how the choice of a background and the way it is used in a composition can enhance and improve a picture. In this project the swirling water, which catches the sun and also has dark shadows in it, dictates the mood and treatment of the seals that are the subject. These seals live on the coast, and their natural habitat is so much better as a backdrop than a concrete zoo pool.

It would have been possible to take out the rocks from the reference photo, but they add texture and balance to the composition. My sketch was fairly simple for this painting, as I wanted to do most of the work with the brush. I began by drawing the shapes of the two seals directly onto the watercolour paper, plus the rock. I then lightly indicated the position of some of the ripples, with a soft pencil.

raw sienna

phthalo blue

ultramarine blue

raw umber

cobalt blue

1 Starting at the top, use a mix of raw sienna and phthalo blue for the first sea washes. Even at this stage, use the white paper highlights to show the flow of the water, and work carefully around the seals, switching to a medium brush around the heads and varying the colours. Allow to dry.

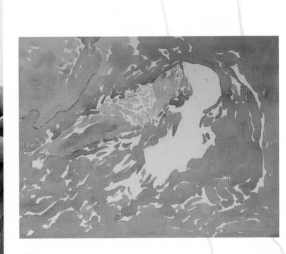

2 Apply raw umber for the rocks and seals, dropping cobalt blue in varying amounts to blend and mix on the paper. Again leave lots of white highlights – you won't be able to add these later. Put in lots of dots and dashes with the smaller brush around the muzzle and whiskers.

103

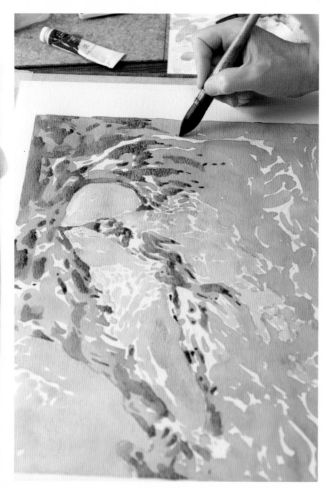

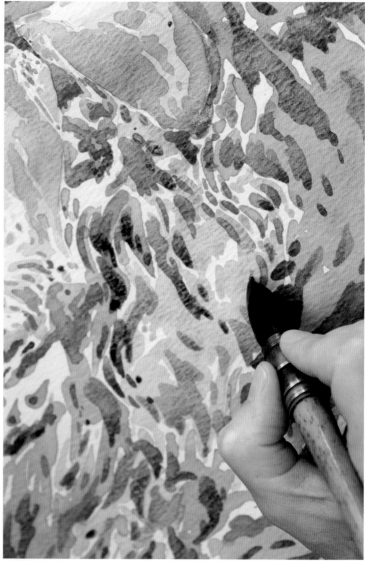

3 Stroke longer directional lines across the seals' backs, and drop in more blue along the bodies, lifting out excess water where necessary. Use varying mixes of ultramarine blue and raw sienna for a darker wash over the water: this should reinforce the flow and still leave a lot of white highlights. Don't forget the little bow wave created by the heads as the seals swim forwards, and add a few dots and tiny marks for where the water splashes across the bodies, using the medium brush.

4 Use raw umber to put in darker marks and lines on the seals and rocks, then drop in cobalt blue as before. With the green mix, first suggest algae on the rocks and then use this mix very lightly on the seals – using the same colours across all the elements of the picture gives a feeling of unity and stops parts appearing as if they are pasted on.

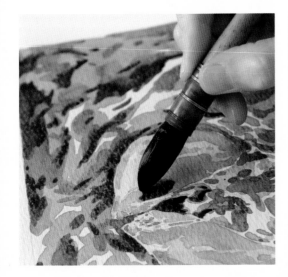

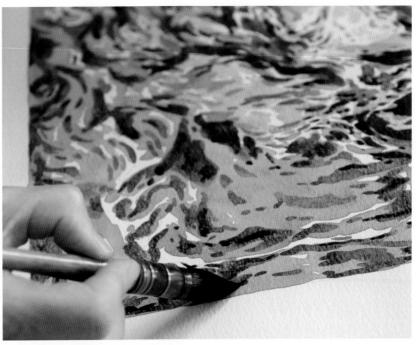

5 Add the darker blue patches both in the sea and on the seals with a mix of ultramarine blue and raw sienna; drop in raw umber on the bodies and rocks.

6 Reinforce all the shadow areas with darker versions of the blue and sienna mixes, deepening and strengthening the washes while still concentrating on the flow of the water and the movement of the seals. As you apply these dark washes, the contrast with the white highlights should become even more striking.

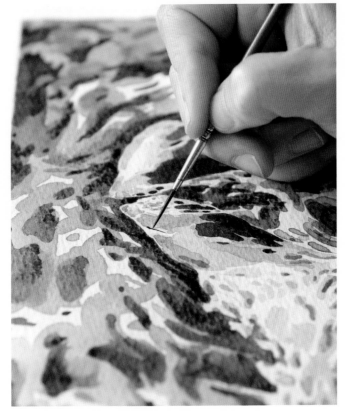

7 Use a No. 2 rigger brush and a very dark mix of ultramarine blue and raw umber to put in the eyes, which are no more than slits, the little shadows around the ears and the dark whiskers. Finish with the same mix for the noses, this time with the medium mop brush.

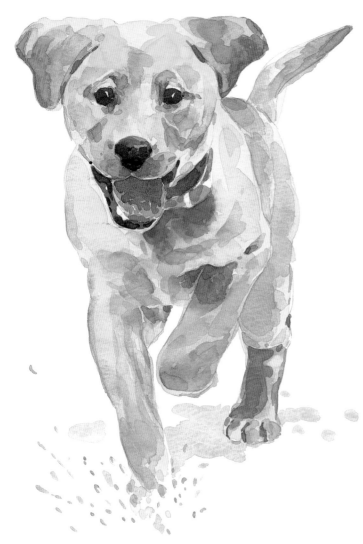

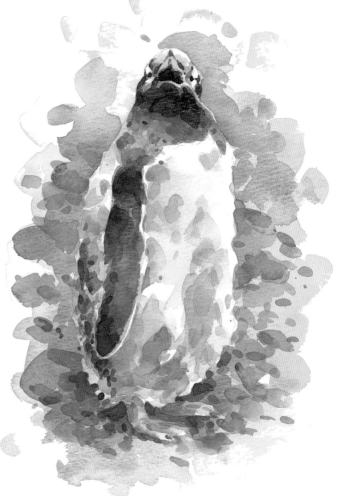

Woody

This Labrador puppy was painted in just a few transparent washes. I kept the painting loose to preserve the lively nature of the subject. I used the paper's whiteness, with the lighter areas receiving just a single, thin wash in places. In the foreground I painted the negative shape of the forepaw around the water splash and used a neutral wash to indicate the droplets of water.

YOUNG ANIMALS

Young animals make appealing subjects, from fluffy chicks to playful lion cubs, but capturing the image can be quite a challenge. Pay special attention to differences in proportion and scale, and resist the urge to 'humanize' your subject.

Young Gentoo penguin

In this painting I used darker background colours to create the negative shape of the bird's light-coloured body. I then painted some loose shadow shapes to maintain the fluffy effect of the softer downy feathers on its breast. Darker shadows were then placed underneath the bird's feet and under its chin.

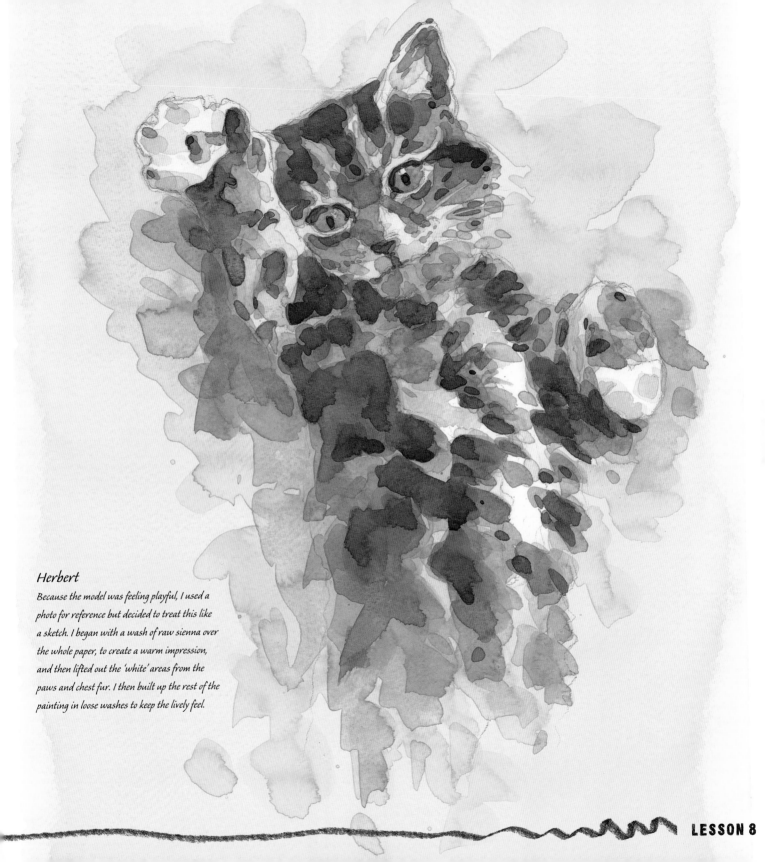

Herbert

*Because the model was feeling playful, I used a
photo for reference but decided to treat this like
a sketch. I began with a wash of raw sienna over
the whole paper, to create a warm impression,
and then lifted out the 'white' areas from the
paws and chest fur. I then built up the rest of the
painting in loose washes to keep the lively feel.*

DIFFERENCES IN PROPORTION

Young animals, like children, differ in appearance and proportion to their parents. The differences in the scale of features and limbs are often what make a young animal distinct from the adult, so it is important to be aware of these characteristics.

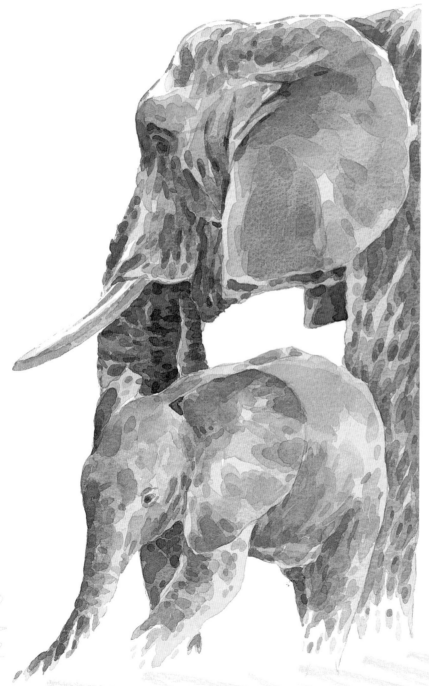

EXTREME DIFFERENCES

In some species the differences are more apparent than in others. Young birds, for example, are either completely featherless or covered in soft, downy feathers. A duckling is alert and ready to swim soon after hatching, but its outward appearance is a lot different to that of the adult birds. Some larger species, such as gulls, take several years before attaining their adult colouration.

YOUNG AND OLD

To depict a young animal with an adult, make sure that both are shown in correct proportion to one another. Mammals, on the whole, are more likely to resemble their parents, but there are usually variations in features, as well as size. Young animals tend to have softer and, sometimes, more appealing facial features to human eyes, but avoid greeting-card-style cuteness.

Some animals resemble miniature versions of their parents, but quite often some features may be of a different scale to the adult. To give you one or two examples, young foals possess very long legs, which gives them a gangly appearance. When they first stand and take their first tentative steps, their legs seem to splay outwards. Young kittens appear to have very large ears for the size of their head, which they grow into. The paws of young puppies also seem outsized compared to those of the adult dog.

Young elephant

The size of this young elephant is suggested by including an adult alongside. As well as a difference in scale, the wrinkled skin of the larger animal indicates that this is an older elephant. The length of the youngster's trunk though, is smaller in proportion to that of the adult.

Young tapir and mother

To give some indication of the relative size of this young tapir, I decided to include only the legs of the parent in the frame. Their size, in comparison to those of the younger animal helps provide some idea of the difference in proportions. The markings too, are different. The dark colouration of the adult contrasts with the lighter markings of its offspring, and the cryptic markings of the young tapir help to break up its outline amongst the vegetation of its natural environment.

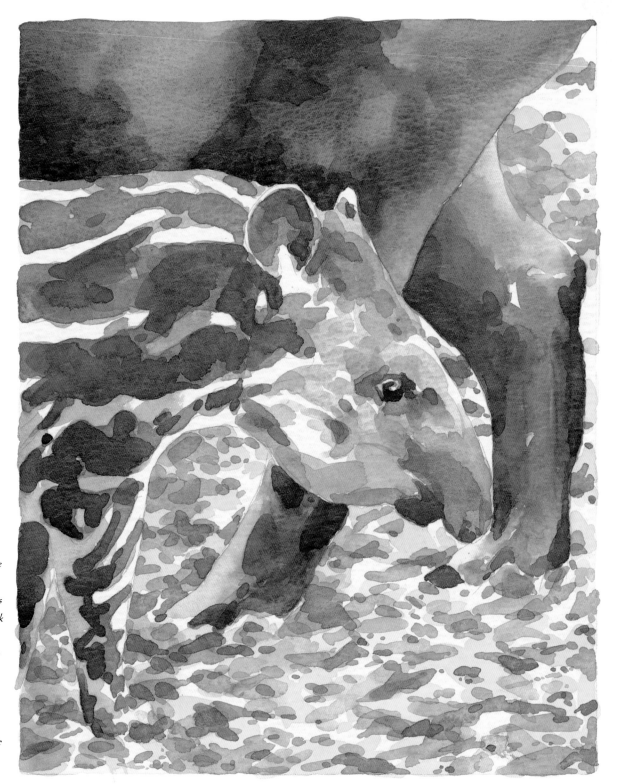

SCALE

Paintings featuring young animals and adults together provide the viewer with some idea of the comparative sizes of parents and young. However, if you are depicting a young animal without including the adult in the same painting, it helps to have some indication of scale in the background if you wish to indicate its size.

DOMESTIC ANIMALS

Paintings of pets can include man-made background features, such as furniture, animal baskets or toys, to indicate scale. Farm animals can be placed in a setting with agricultural features – stables, pens or perhaps farming equipment and machinery – as a backdrop.

WILD ANIMALS

Wild animals, however, require a little more thought. Natural features such as plants and flowers give a good indication of scale when placed alongside the main subject. Vegetation can also be worked into the design of your painting to make an interesting composition, and colourful flowers can be included to complement the colours of the animal. Care must be taken, however, to ensure that any plants you include occur naturally in the same habitat as your subject.

Study the environment in which you want to place your subject. Small birds and animals will use rocks and branches to perch on. Ask yourself how large the animal is in comparison to its setting. If you are painting a mouse, then it follows that a small twig or branch will best illustrate the scale of the animal. Similarly, larger species can be placed in settings that will suggest their size in relation to their environment. Try to be creative with your settings. The person who is viewing your painting should be able to determine the scale of your subject without asking.

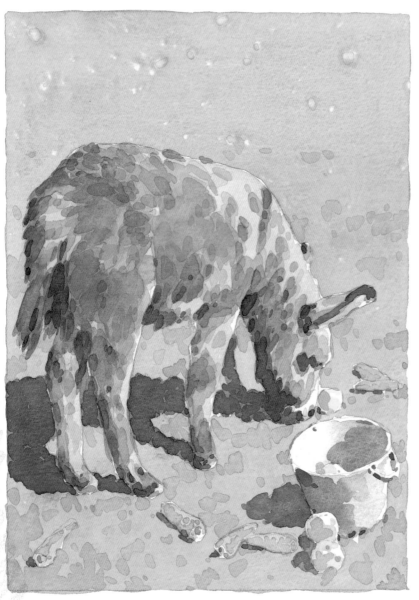

Young donkey
The shaggy coat of this donkey suggests that it is a young animal. However, I also included the bucket to provide some scale, suggesting that the animal is small.

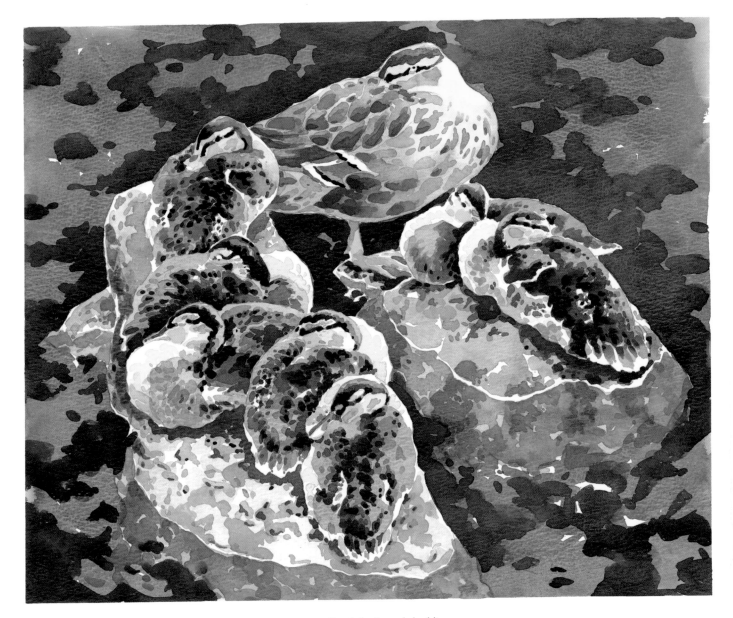

GETTING THE DETAILS RIGHT

Spend some time researching items you may wish to include in your painting. There are a lot of knowledgeable people out there who spend hours in the field studying wildlife and the countryside. You really don't want to have any glaring mistakes in your work, as they will be easily spotted. If you want to earn a reputation for accuracy, then it is crucial that you take every care to ensure that you have made no errors, as bad mistakes can be with you for a long time.

Mallard duck and ducklings

You don't have to travel far to find inspiration. I was on my way back from the shops, when I came across this mallard duck and her young brood. She had chosen a concrete-walled stream in the middle of town on which to raise her ducklings. For the painting, I resisted the 'fluffy, cute' approach, instead coming up with an interesting design. I settled for a circular composition, with the adult at the top. Although the ducks are at rest, you can sense that they are still alert and watchful. Obviously the ducklings are smaller in scale, in comparison to the adult. At this stage in their growth they appear to be about half the size of the parent. I was careful to ensure that I made them all the same size.

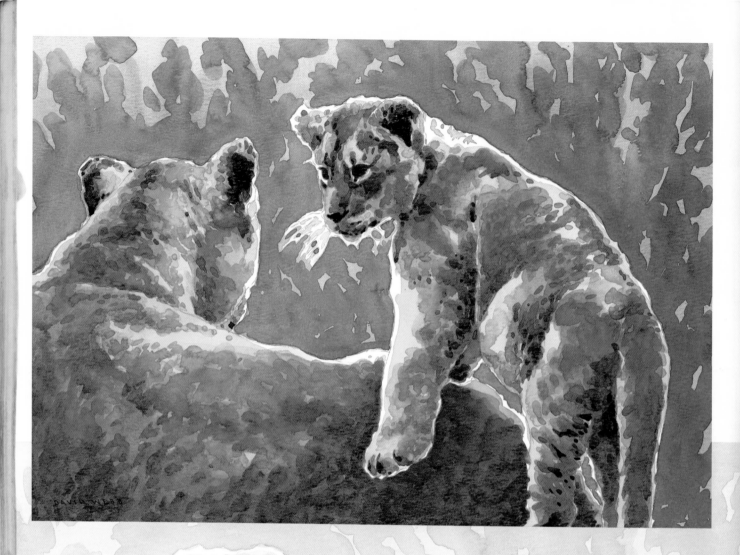

Jamna and her cub Sahan

All the mixes for this project were made from just four colours. When using phthalo blue, be warned that it is a very strong staining pigment, so add it to the mix in tiny amounts until you get to where you want – adding other colours to it won't work.

LION CUB

You can see the difference in size between a cub and an adult lion clearly here (see also pages 58 and 59 for adult lion heads). In this pose, the negative spaces between the cub and the lioness in the centre and to the right are very important aids to help establish not only the proportions and the spatial relationship between the animals, but also the mother and cub link.

I took this shot at my local zoo a couple of years ago, so the cub is no longer a cub. The muted light from above right means that there are no strong shadows, but as the light strikes the rim of fur it creates a halo effect. For the sketch, I began with a carefully drawn outline on the watercolour paper of the lioness and cub. I paid particular attention to the negative space between them.

 phthalo blue

 ultramarine

 burnt sienna

 raw sienna

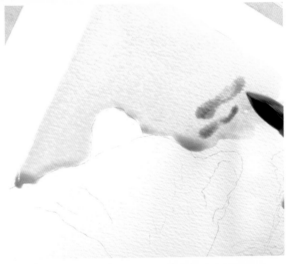

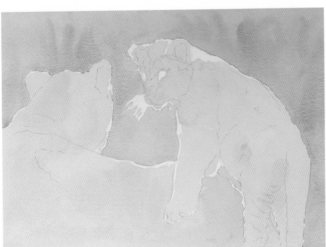

1 Painting around the negative shapes of the lions, start with a very watery wash of raw sienna and a tiny bit of phthalo blue. While this is wet, drop in a mix of burnt sienna with a little ultramarine, again with a lot of water in the wash. It helps if the board is tilted slightly, as you can work down from the top left and use the brush to spread the washes in the area; soak up any hard edges and runs with a damp, clean flat brush. Work around and in and out of the whiskers, and allow everything to dry completely.

2 Use a wash of raw sienna and one of raw sienna with a little burnt sienna for the first overall washes on the bodies. Work quickly wet-in-wet, and remember to leave the rimlight halo, highlights and the cub's whiskers and eyes as white paper. Drop in a few contour lines down the edges of the cub's legs while everything is wet, using both siennas, and let it all dry again.

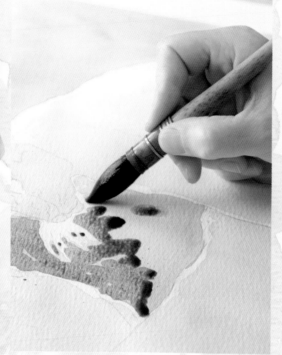

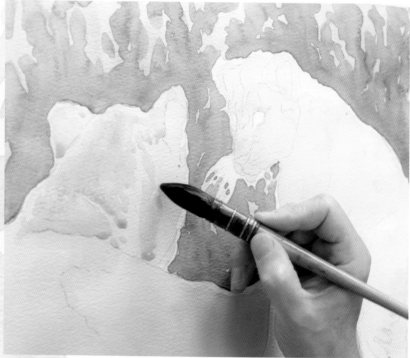

3 Make a green wash from burnt sienna and ultramarine and apply this to strengthen the background. While this is wet, drop in a mix of burnt sienna and a little phthalo blue, to give an impression of a lush background. Once again, be careful to leave the white parts untouched.

4 Use the same washes to the right of the cub and in the tiny negative spaces, then start to show the darker patches of fur on the lioness, first with raw sienna and then burnt sienna. Keep to broad strokes and shapes without any detailing, and don't cover all the first, dry washes, but let them show through here and there for contrast.

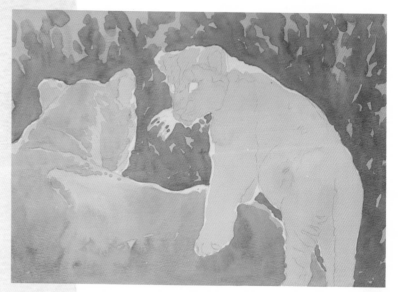

5 For the shadows at the bottom left and below the cub's paw add a little ultramarine to the burnt sienna, dropping this into the wet washes. Allow to dry. At this strage the cub is a negative shape, and the washes have added light and shade.

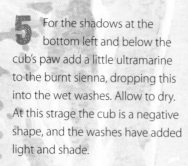

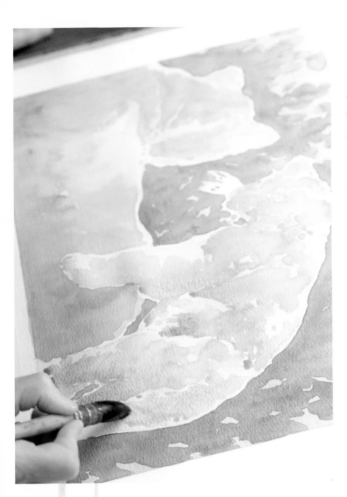

6 Use the same washes for the cub's fur: keep the highlghts and rimlight haloes white, but drop in a little colour on the eyes. Start to darken a little detail on the cub's face – the characteristic 'frown' around the forehead and eyes – and then move onto the back and body. There are more small patches of dark and light fur than on the lioness, but the front leg is still light against the larger body.

7 Use stronger separate washes of raw sienna and burnt sienna, and a mix of burnt sienna and ultramarine to darken both bodies. Dab on the washes to suggest the texture of fur, and work the colours into each other while wet. Make the colours even darker below the cub's paw and at the bottom of the lioness's body.

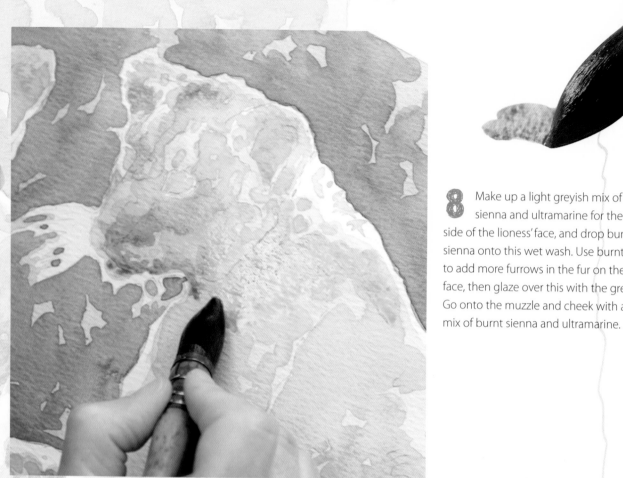

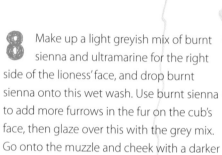

8 Make up a light greyish mix of burnt sienna and ultramarine for the right side of the lioness' face, and drop burnt sienna onto this wet wash. Use burnt sienna to add more furrows in the fur on the cub's face, then glaze over this with the grey mix. Go onto the muzzle and cheek with a darker mix of burnt sienna and ultramarine.

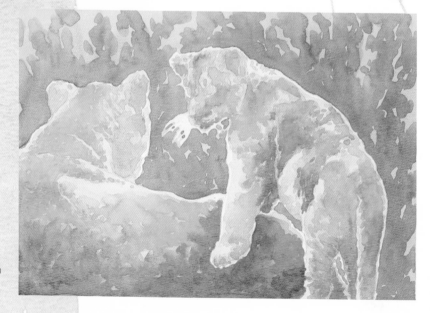

9 Use quite concentrated burnt sienna for the orange on the cub's back and shoulder, building up the curves and contours. Accentuate the darker patches where the front leg meets the body, leaving light lines to delineate the edges of both legs. Soften any hard edges with clean water.

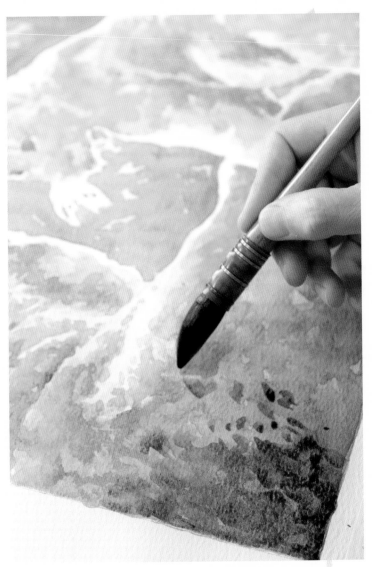

10 Use a dark mix of burnt sienna and ultramarine for the eyes, then go onto the back of the lioness's ears with this mix, still leaving the rimlight white. As you move down the neck, warm the mix with more burnt sienna, and add more ultramarine for the suggestions of individual clumps of darker hairs.

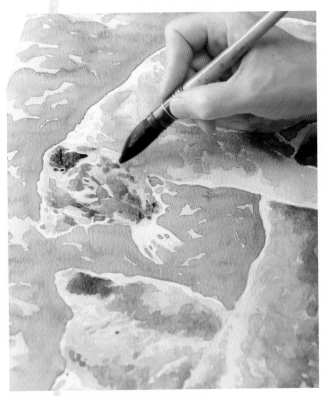

11 Start the details on the cub's face with the same mix, working from the ear on the right and going across the furrows into the nose and cheek in shadow. Leaving the whiskers, go around the head and down onto the neck and body.

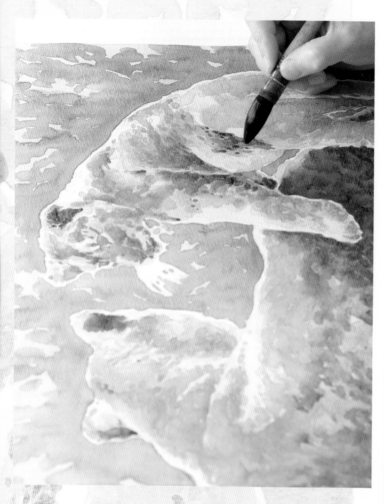

12 At this stage you are both reinforcing the darker areas and adding details: as you dot and dab tiny bits of shadow onto the front leg, lift out the paint around them for greater contrast. Move onto the body with both the dark washes, using the light and shade to show the separation of hairs in the fur. Apply a dark streak down the middle of the tail to throw the sides into the light.

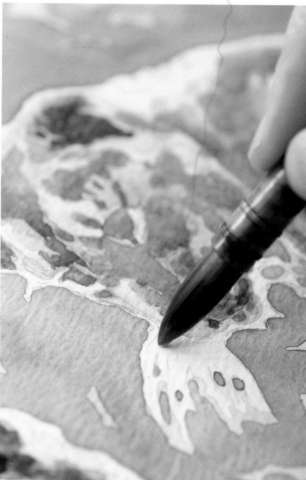

13 For the darkest parts of the ears use a medium mop brush and quite strong mixes of burnt sienna and ultramarine – add the blue for a darker effect and the sienna for a warmer feel. Now you should be looking for the smaller details to pull everything together, such as the line down the back of the lioness' neck.

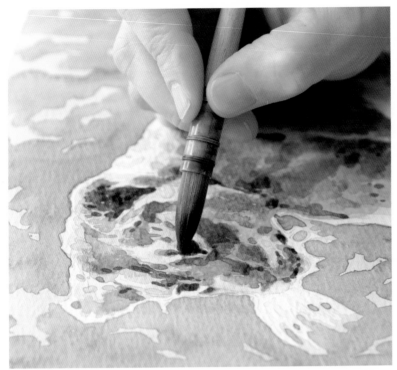

14 Add some watery raw sienna among the whiskers to show their line and direction – the light is coming from behind them, so they should still be very pale. Then use a dark mix for the last parts: the inside of the ear, the mouth and the shadows around the head and the legs, just making small marks and lines. Finish with the divisions on the paws, the shadows around the tail, the eyes again and the tiny visible part of the lioness's mouth.

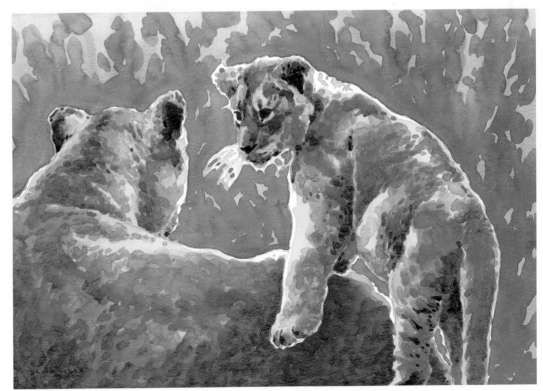

The overall effect of the finished painting is one of strong background light that puts the animals into strong relief and also keeps all the colours quite pale. The indistinct background focuses attention on the lions.

INDEX

ACKNOWLEDGMENTS

I'd like to thank a few people for making this book possible, in particular Freya Dangerfield, Sarah Underhill, Jennifer Fox-Proverbs and Emily Rae, from David & Charles, and Ian Kearey, for their enthusiasm and teamwork from start to finish. I'd also like to thank Kim Sayer for his great photography, despite the fact that his dog ate some of my painting equipment. Thanks also to the staff of Paignton Zoo and the many people who allowed me to include their various pets in the book.

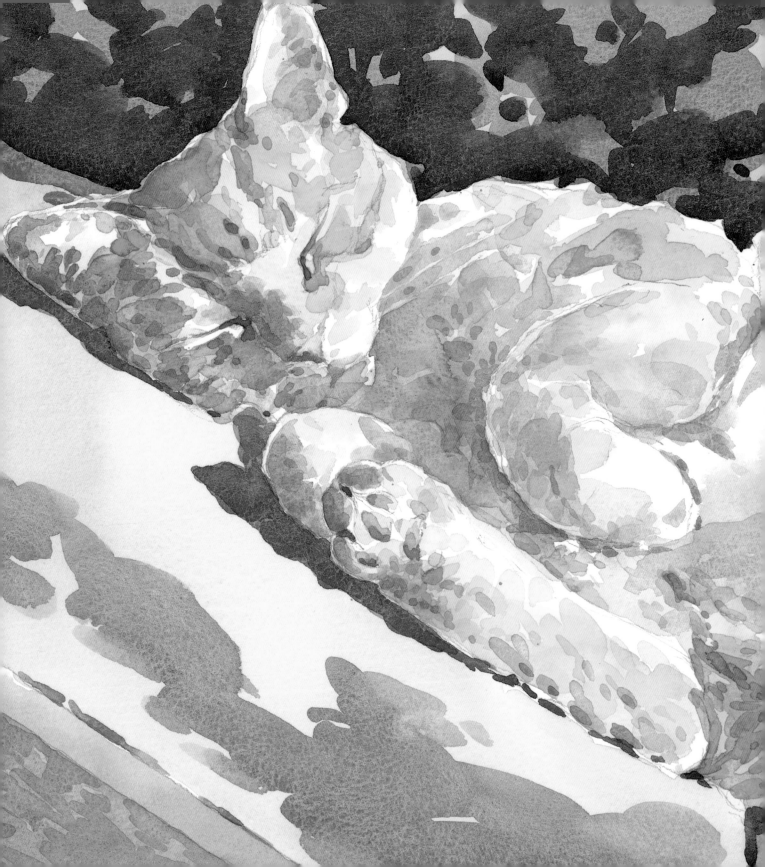

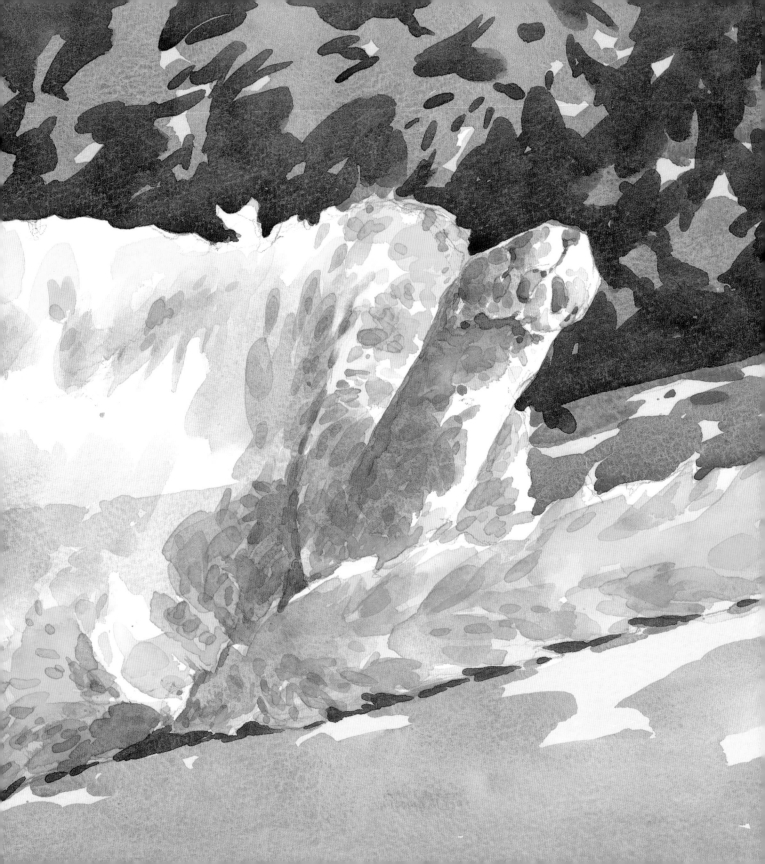